Fantasy Floral Quilts
Creating with Silk Flowers

Bonnie Lyn McCaffery

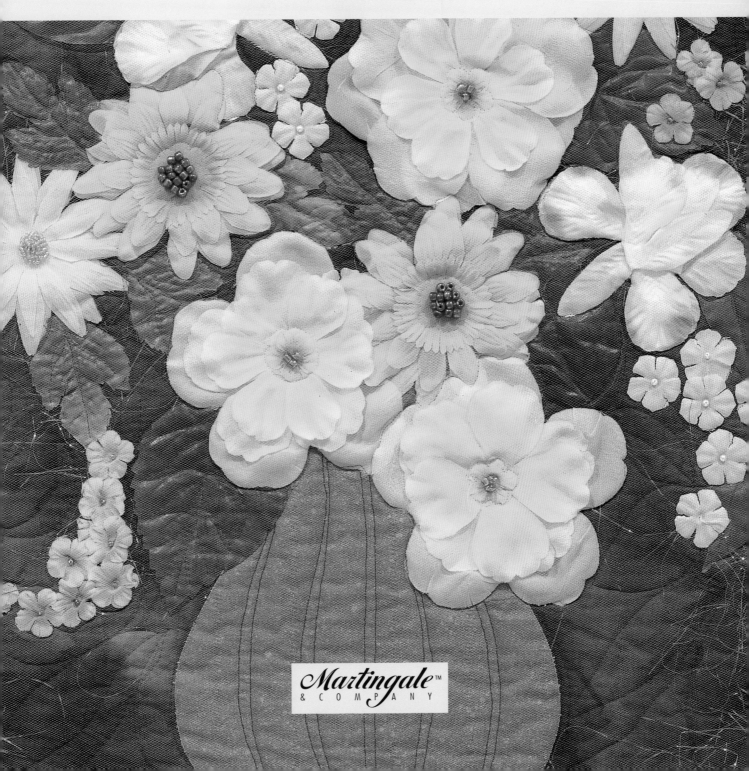

Martingale™
& COMPANY

Martingale™
& C O M P A N Y

That Patchwork Place® is an imprint of
Martingale & Company™.

Fantasy Floral Quilts:
Creating with Silk Flowers
© 2001 by Bonnie Lyn McCaffery

Martingale & Company
20205 144th Avenue NE
Woodinville, WA 98072-8478 USA
www.martingale-pub.com

President Nancy J. Martin
CEO Daniel J. Martin
Publisher Jane Hamada
Editorial Director Mary V. Green
Managing EditorTina Cook
Technical Editor Ursula Reikes
Copy Editor Ellen Balstad
Design and Production Manager .. Stan Green
Illustrator Laurel Strand
Photographer Brent Kane
Cover and Text Designer Stan Green

Printed in Hong Kong
06 05 04 03 02 01 8 7 6 5 4 3 2 1

Library of Congress Cataloging-in-Publication Data

McCaffery, Bonnie Lyn.
 Fantasy floral quilts : creating with silk
 flowers / Bonnie Lyn McCaffery.
 p. cm.
 ISBN 1-56477-387-6
 1. Quilting—Patterns. 2. Appliqué.
 3. Flowers in art. I. Title.
TT835 .M22 2001
746.46'041—dc21 2001044167

Mission Statement
We are dedicated to providing quality
products and service by working together
to inspire creativity and to enrich
the lives we touch.

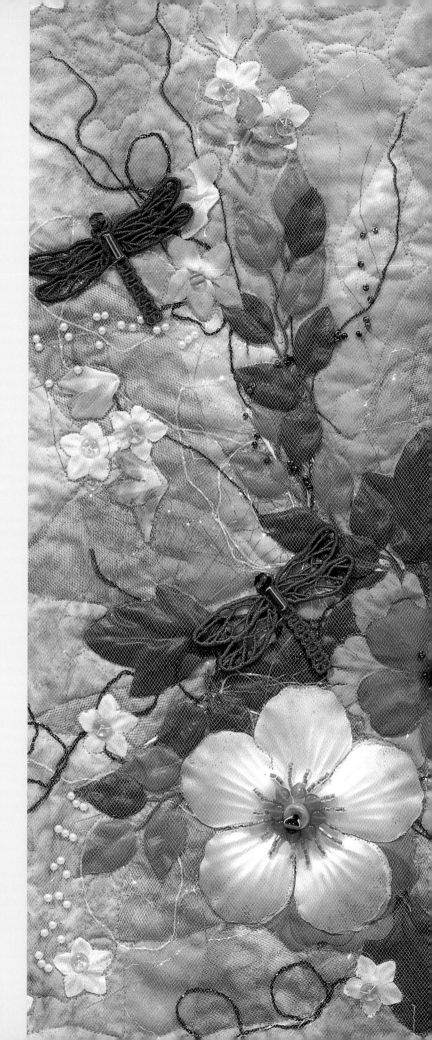

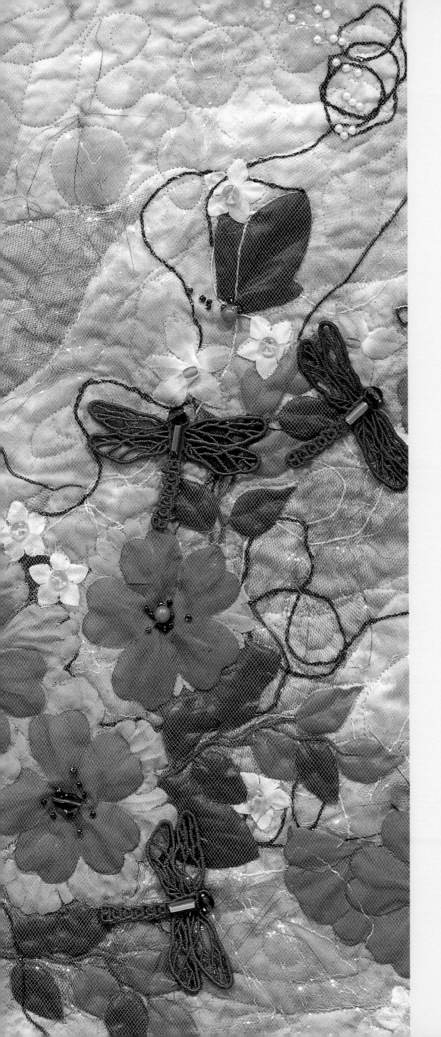

Dedication

We are all blessed in different ways. I happen to have a wonderful family. My twenty-year-old daughter, Heather, shows me strength and determination. Carly, my seventeen-year-old daughter, shows me that you can achieve anything you set your mind on. Abby, my sixteen-year-old daughter, has shown me how hard work can get you to the top. My husband, Michael, is an amazing man who supports me in everything I put my mind to. It is to this wonderful family that I dedicate this book.

Acknowledgments

I would especially like to thank the following companies for their generous contributions that made many of the quilts possible: Teters Floral Products, Inc.; Timeless Treasures Fabrics, Inc.; Hoffman California International Fabrics; Textile Creations, Inc.; Clover Needlecraft, Inc.; Creative Crystal Company; Falk Industries Inc.; YLI Corp.; Prym Dritz Corp.; Hunt Manufacturing Co.; JHB International Inc.; Freudenberg Non-Wovens; and Beacon Chemical Co., Inc.

Thank you to Carly McCaffery, my daughter, for doing a great job on the preliminary editing.

Thank you to the Milford Valley Quilters, who have continued to encourage me and act as test students.

I am also grateful to the following quilters who agreed to have their quilts published in this book: Valerie V. Morton, Patti Shreiner, Mary Murray, Helen Umstead, Monica Cespino-Dowd, Dee Houston, Sue C. Powell, Barbara Broshous, Lillian Angus, Elaine Reuschlein, Susan Sladek, Maria Weinstein, Debra Lynn-Wiegand, Bridget Sarosi, Julie Liggett, Kathy Klein, Kathleen Ventura, Mary Alice Peeling, Tülin Alacaatli, Lori Nixon, and Laura M. Orben. It is their quilts that make this book come to life.

Contents

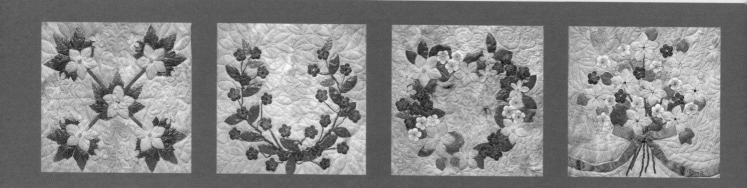

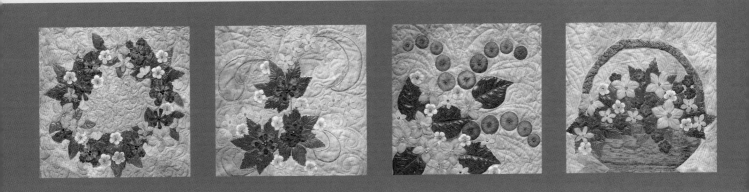

Introduction

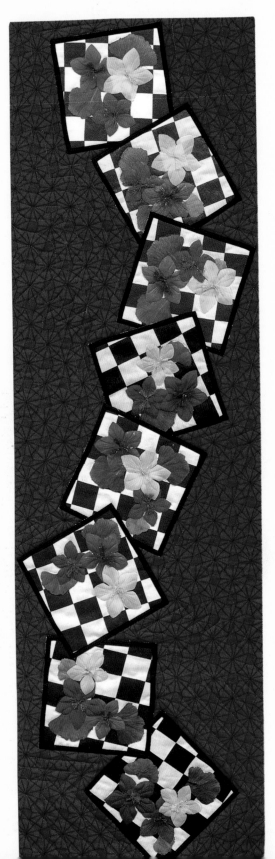

IN TODAY'S LIFE OF OVERFULL CALENDARS, TIME IS A VALU-ABLE COMMODITY. I love beautiful floral quilts, but I never imagined I'd ever have enough time to complete one using the traditional methods of appliqué. However, in 1997 I saw a quilt by Sharon Lee Williams on which she stitched silk flowers to the quilt surface. Her quilt was my initial inspiration to incorporate silk flowers into fantasy fabric, a type of layered fabric that I explain in great detail in my first book, *Fantasy Fabrics: Techniques for Layered Surface Design* (Martingale & Company, 1999). The idea behind fantasy fabric is to position a broad range of items, including silk flowers, on a background fabric and cover these items with a sheer layer of fabric to capture them. The layers are stitched together to create a new fabric that can be framed, pieced, or appliquéd into a quilt. Though I include a short section in *Fantasy Fabrics* on using silk flowers, I realized that there was so much more that could be done with them.

Each section of this book offers lots of information about the different types of quilts that you can create with silk flowers. The section "Twisted Branches" on page 27 will show you a great technique for creating branches that look realistic. The "Bouquet Quilts" section on page 31 will give you tips on how to arrange different styles of floral designs. In "Silk-Flower Color Play" on page 36, you will learn about creating areas of color and texture with silk flower petals. At the end of the book, there are a number of projects that incorporate this information.

So, come along with me on an adventure to create, in an incredibly short time, beautiful floral quilts with silk flowers.

COLORATIONS by Bonnie Lyn McCaffery, 2000, Hawley, Pennsylvania, 13" x 41". Various colors of tulle cover identical blocks in this quilt. Starting from the top down, the tulle colors are white, yellow, orange, red, lavender, blue, green, and black. The flower centers are embellished with thread ties of YLI Candlelight Metallic Yarn.

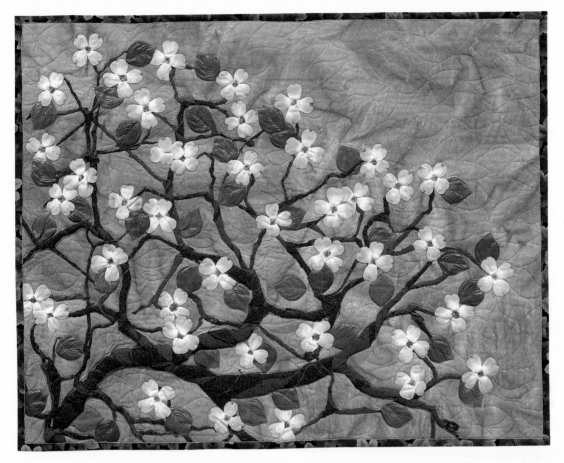

Above: GRANDMOTHER'S DOGWOOD by Bonnie Lyn McCaffery, 1999, Hawley, Pennsylvania, 37" x 29". Bonnie's grandmother Emma Sybella Birchall loved her dogwood tree, so this quilt is dedicated to her. The branches are the result of the twisted branch technique described on page 27. The flowers, dabbed with a dot of glue and then dipped into a multicolored mixture of beads, are under a layer of tulle.

Right: CHRISTMAS MEDALLION by Valerie V. Morton, 2000, East Longmeadow, Massachusetts, 40" x 40". Blue Iridescent Tintzl and metallic and non-metallic Christmas silk and polyester flowers are layered on black velveteen. Iron-on rhinestones sparkle in the centers of flowers.

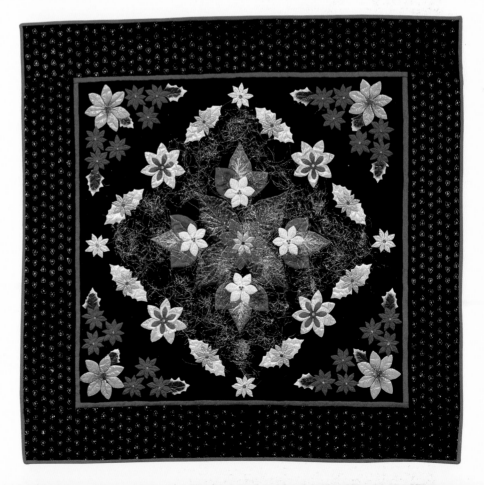

Supplies

Background Fabrics

Each design requires a background fabric on which to place the silk flowers and additional embellishments such as ribbons and beads. This fabric can be any woven fabric you are comfortable stitching, which leaves your options wide open. Cottons are a great choice. They are easy to stitch through and come in an assortment of patterns and designs. Suede cloth has a wonderful, soft visual texture that contrasts nicely with silk flowers. Brocades offer a rich background texture for the flowers. Valerie V. Morton used black velveteen to set off her quilt, "Christmas Medallion," shown on page 7. Before you make your final decision, however, determine the use of your project. If you plan to use it for clothing or something that may need to be cleaned, consider the washability of the background fabric as well as the flowers.

Top Fabrics

The fabric placed on top of the completed design needs to be sheer so the silk flowers and other embellishments will show through. My favorite top fabric is fine tulle, which is so sheer it is almost invisible on the quilt. The color of the tulle affects the coloration of the flowers as well as the background. For example, white tulle softens the colors and gives a pastel appearance. Black adds shading and darkens the design. Look at "Colorations" on page 6 to see how each block is affected by the color of the tulle on top.

Tulle is fairly inexpensive, so it is worth buying several different colors and experimenting to see which one will achieve the desired look. Soon you will become comfortable at selecting the appropriate color of tulle.

Stabilizers

You will need a firm tear-away stabilizer to help keep your project flat while you stitch the layers together. I love Pellon Stitch-n-Tear because it can be ironed if it's wrinkled, which is very important. One time I mistakenly used stabilizer that disappeared when ironed and reappeared on the soleplate of my iron. Be sure to read the manufacturer's directions to determine if the stabilizer you are using can be ironed. Note that the purpose of the ironing is to flatten the stabilizer, not to adhere it to the background fabric.

Flowers

We will be looking at a wide range of silk flowers that you can incorporate into your beautiful creations. I use the phrase "silk flowers" lightly. The vast majority of the flowers are actually polyester or some mixture of fiber content other than silk. Therefore, when I use the phrase "silk flowers," I'm actually referring to all artificial flowers.

Look for flowers that can lie flat or be folded. Delphiniums, lilacs, lilies, azaleas, and chrysanthemums are all great choices. Keep in mind that the flowers will be taken apart. The petals from one chrysanthemum may yield at least two or three flowers. Delphiniums are my favorite because you get four different sizes of flowers when you take them apart, as shown in the photograph at right.

Not all artificial flowers available are appropriate for capturing under tulle. For example, while an artificial rose may be beautiful on the stem, once it is opened and flattened it will no longer look like a rose and it will be too bulky if flattened on its side. And beware of flowers with faux water droplets. The water droplets are usually made of plastic that will melt from the heat of an iron.

A wide variety of silk flowers can be used to create floral quilts.

Also note that there are some artificial flowers on the market that have a thin piece of wire glued between two petals. These flowers are much more difficult to use because you will need to be careful and avoid the wires when stitching.

Embellishments

Here are a few items you might want to have on hand to embellish your designs. Specific guidelines for using these items are explained in "Adding Embellishments" on pages 41–47.

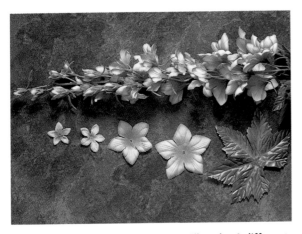

When taken apart, a delphinium will make 4 different-sized flowers.

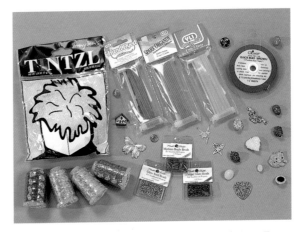

Embellishment supplies: Tintzl, Clover Quick Bias Tape, buttons, beads, Creative Crystal Iron-On Rhinestones, decorative threads, and silk ribbons.

• Beads in all varieties and sizes, such as seed beads, bugle beads, wooden beads, metallic beads, and textured beads, can be used to enhance the flower centers.

• Buttons and charms in all sizes and shapes are great for adding interest to flower centers and backgrounds.

• Clover Quick Bias Tape is a pre-made bias tape that can be easily positioned and fused to fabric. This bias tape makes nice stems.

• Creative Crystal Company (see "Resources" on page 79) offers a wonderful selection of heat-applied, Austrian-crystal rhinestones; metallic studs; and pearls. These items have heat-sensitive glue on their backs, which melts when heated and adheres them to the fabric. They add a great sparkle to flowers. Creative Crystal Company also makes the BeJeweler, a handy tool that heats and sets rhinestones.

• Silk ribbons, yarns, and decorative metallic threads can be stitched onto flower centers.

• Tintzl is fun to add as background texture. This product is similar to Christmas tree tinsel and is available in a wonderful assortment of colors. It can be difficult to find, so refer to "Resources" on page 79 for information regarding companies that sell Tintzl.

Additional Tools and Supplies

It's always nice to have the right tools for the right job. The following list represents the basic tools and supplies you will need to create a fantasy floral quilt.

• AIR-ERASABLE MARKING PENS. Use these to temporarily mark an area for flower placement. The marks are visible for up to 8 hours and disappear without having to immerse the project in water.

• DARNING FOOT OR FREE-MOTION SEWING MACHINE FOOT. Use this foot for free-motion stitching when sewing the layers together. You can use a regular sewing machine foot, but every time you want to stitch around a flower you will need to lift the presser foot and rotate the project. This action can significantly increase the time it takes to stitch a project. While it is possible to stitch this way, it certainly would not be my choice.

• GLUE. While many of these projects can be made without glue, it can be useful when a flower or leaf must remain in a specific location. Most of the glues that I have experimented with leave what looks like a wet spot on the flower when it dries. However, I have found one glue that seems to do the job. It is called Fabri-Tac by Beacon, and can be used sparingly to hold a flower in place. To glue beads and pearls in place, I use Gem-Tac, also from Beacon. It is used in the bridal industry for adhering beads and pearls to bridal wear. Be sure to test the glue on the specific bead, flower, and fabric.

• IRON CLEANER. You will need this cleaner in case you accidentally set the iron temperature too high while pressing tulle or flowers.

• JEWELRY PLIERS. These pliers are helpful for removing flowers and leaves from branches.

• LINT ROLLER. Use this tool to remove particles from the background.

• NEEDLES. The choice of sewing machine needle is affected by the thread you choose for stitching the layers together. A thin needle will keep the bobbin thread from showing on the top surface. A size 60/8 is the best choice for fine threads like the transparent threads. The drawback to this needle is that it is very fine and breaks easily if it is caught in the fabric while free-motion stitching. If you use this needle, stitch and move your hands slowly, and have a package of needles on hand to replace it when it breaks. A size 70/10 universal needle is a little thicker than the 60/8 size. It is a little less likely to break, but it does create a slightly larger hole.

If you are using a metallic thread, it is critical that you use a sewing machine needle especially designed for metallic threads, like a Metallica or a Metafil needle. Loosen the top tension on the thread a bit and stitch a little slower than normal. This, combined with the metallic needle and a quality metallic thread, will eliminate the headaches and distress of stitching with metallic threads.

You will also need hand-sewing needles to add your embellishments. Sharps, which are thin

hand-stitching needles with small eyes, are good for finer threads required to stitch beads. Sharps are also used for hand-stitching and embroidery. A chenille needle has a long eye and a sharp point. It is good for stitching heavier threads, yarns, and ribbons. The most important thing is to use a needle that has a good, sharp point to pierce the silk flowers.

• PINS. You will need many pins to secure the layers together. I like the large-headed pins because they are visible and I won't stitch over them with my sewing machine. You will also need small-headed pins to hold items in place while laying the tulle over the top. The small-headed pins will pop through the tulle, allowing you to remove them once the items they are holding are secured.

• ROTARY-CUTTING EQUIPMENT. You will need a rotary cutter with a sharp blade, an acrylic ruler, and a large cutting mat to cut fabrics and square up the design.

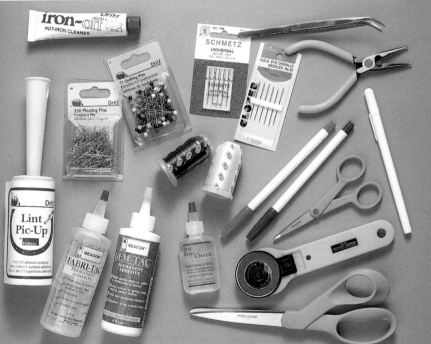

Tools: Scissors, temporary marking utensils, invisible thread, Gem-Tac, Fabri-Tac, Fray Check, size 8-10 sewing machine needles, large and small head pins, lint remover, iron cleaner, and rotary cutter.

• SEWING MACHINE. The best way to stitch the layers together is with free-motion stitching. Be sure that your machine is in good working condition.

• SCISSORS. You will need a pair for both paper and fabric.

• SPRAY STARCH. Use spray starch to stiffen cotton fabrics, which is helpful for background fabrics and novelty fabrics from which you may cut motifs.

• THREADS. Threads are what hold the layers together. The bobbin thread should be similar to the color of the items being stitched. I often use a neutral gray or tan thread if the central design is medium colored.

The top thread can be any thread you are comfortable using in your sewing machine. I prefer that the stitches do not show, so I use YLI Wonder Invisible Thread (a transparent thread). It is available in smoke and clear. Use the clear in light-colored areas and the smoke in dark-colored areas. You may need to loosen the top tension on the sewing machine when stitching with the transparent thread.

A colored or metallic thread can be used if you want the stitches to show on the top surface. My personal favorite metallic thread is YLI Fine Metallic Thread. I have had great success using this thread.

• TWEEZERS. Use tweezers to remove tiny bits of stabilizer or tracing paper.

BOUQUET OF SUNSHINE detail; see page 30 for full quilt.

The Basic Steps

THIS BOOK COVERS EVERYTHING YOU NEED TO KNOW ABOUT MAKING FANTASY FLORAL QUILTS. Let's start with the basic steps to introduce you to the process.

1. Start by cutting a piece of background fabric slightly larger than the desired finished quilt size. Allow ¼" for seam allowances plus ½" for squaring up the fantasy floral fabric. The background fabric will be trimmed once you stitch the layers together. When ironing, use spray starch on the back of the background fabric to make the fabric stiffer and to help it lie flat.

2. Cut a piece of tear-away stabilizer the same size as the background fabric. Press the stabilizer with an iron; it is not necessary to use spray starch. If the background fabric is wider than the stabilizer, overlap 2 pieces of stabilizer by about ½". Temporarily pin the 2 pieces of stabilizer near the outside edges. Remove these pins once the layers have been pinned together and before you start stitching.

3. Working on a firm, flat surface, position the background fabric on top of the stabilizer. Do not work on a covered ironing board or you may end up pinning the pieces to the ironing board cover.

4. Now the fun begins. Carefully pull the flowers off the stems. Use jewelry pliers to assist you in pulling the flowers off.

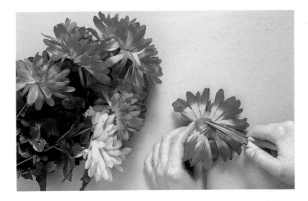

Use jewelry pliers to take numerous flowers apart.

5. Separate the layers of the flowers and remove the plastic parts from between the layers. Use your fingernails or pliers to peel off these plastic parts. Then restack the layers, placing the largest layers on the bottom and the smaller layers on the top. Use the least amount of layers possible to convey the look of a flower.

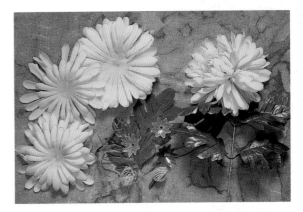

One multilayered flower will yield several flowers.

Keeping the number of layers low will reduce bulk and make stitching easier. You will be able to create two or three new flowers from one multilayered flower.

NOTE: *The fiber content is often difficult to predict, so it is best to protect the ironing surface and the iron. Place a piece of copy paper on the ironing surface, lay the flower on the paper, and cover the flower with another piece of paper. Now you can press the flower safely.*

6. Remove the plastic stems from leaves by peeling carefully from the stem. Press the leaves as described above in the "Note." The glue used to adhere stems to the back of the leaves may remain on the leaves and melt from the heat of the iron, so protect your iron and ironing surface. Leaves are often connected in groups of two to five with a small plastic hole in the center. You can use the group of leaves as is, covering the hole with a flower, or you can cut the leaves apart and use them separately. To use individual leaves, cut the base of the leaf at an angle to create a natural-looking leaf end. You can also fold groups of leaves in half to create an interesting arrangement.

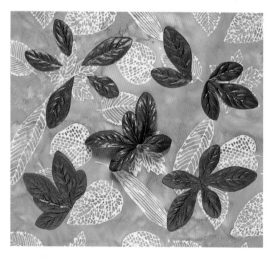

A multileaf unit can be folded or cut apart.

7. Position the flowers and leaves on the background fabric to form a pleasing design. If it is critical that the items remain in a specific location, lightly glue them in place with Fabri-Tac. Using a tiny dot of the adhesive on the back of the item, place it in the proper location and apply a little pressure to make it stick to the background fabric. Let the glue dry completely before stitching.

8. Once you position the flowers and leaves, inspect the background for any loose threads, fuzz, or plastic flower parts. Remove these prior to covering with the tulle.

9. Place a layer of tulle on top of the flowers, leaves, and background fabric. If you want to experiment with different colors of tulle to see how they affect the look of your arrangement, DO NOT lay the different-colored tulles on top of the design. Every time you lay the tulle down and pick it up, the tulle moves the flowers and leaves. Instead, position your design close to the edge of a table. Take the "auditioning" tulle and hold it by the top two corners. While it is perpendicular to the table, let the edge of the tulle hang just below the edge of the table and trap it there by pressing your legs against the tulle and the table. Then lower your hands slightly so the tulle is at an angle over the design without touching it. Look through the tulle and get a preview of what it will look like. Audition each of the possible colors this way until you find the perfect choice. Don't be afraid to try colors you think will not go. I have seen students experiment with a color they are sure will not go, and find that it is the perfect choice.

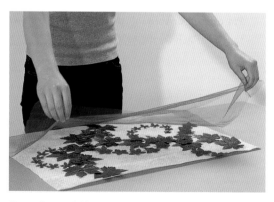

To audition different colors, hold tulle at an angle over your work.

10. Once you make a decision regarding the color of the tulle, cut a piece slightly larger than the background fabric. Press the tulle to remove any wrinkles.

CAUTION: *Tulle is very sensitive to heat. Lower the iron temperature and test in a corner before pressing the entire piece.*

11. Lay the ironed tulle on top of the design, keeping it as flat as possible. Hold down the layers with one hand and pin with the other hand. Working from the center out, pin the layers together with enough large-headed pins to hold the flowers and leaves in place. Place pins through the center of flowers or around the outside of them. Avoid pushing a pin through the petals of the flowers and leaves; this often leaves holes in the fabric.

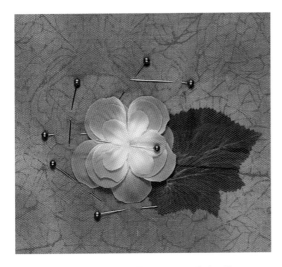

Pin around or through the center of the flower to temporarily hold the layers together.

12. Prepare your sewing machine for stitching. The purpose of the stitching is to hold the layers together. It is not necessarily a decorative element, although it can be if you choose colored thread. If you don't want the stitches to show, use a transparent thread. If there is a strong contrast between the flower color and the background fabric, the bobbin thread may show if you stitch on top of the flowers. In this case, stitch around the flowers rather than through the center of them.

You can use a walking foot and a normal straight stitch if you don't mind turning the fabric layers as needed. I prefer to use a darning foot or free-motion foot and free-motion stitching. Free-motion stitching allows the fabric to move freely in any direction under the foot of your machine, and you determine the length of the stitches. If you have a "heavy" foot and slow hands, your stitches are going to be very small. A "light" foot and fast hands will produce larger stitches. It is a matter of practice to achieve the right-size stitches. Don't be afraid to get some speed with your foot. Whenever I teach free-motion stitching, I'm always saying, "Faster foot, slower hands."

Most sewing machine manufacturers recommend that you lower the feed dogs when free-motion stitching. I have a Bernina 1130, and I have also sewn on a Bernina Artista 180. After experimenting, I found that leaving the feed dogs up helps to feed the layers at an even pace. However, the decision for leaving the feed dogs up or down is up to you. You may want to experiment a bit to see what works for you and your machine.

To keep from making large stitches at the beginning and ending of your stitching, follow these two simple rules. Whenever you start stitching, press your foot on the pedal first and then start to move your hands. When you come to a place where you want to stop, stop moving your hands first and then stop pressing on the pedal.

13. When you are ready, stitch the layers together. Start stitching along the outer edge of the background fabric and go immediately into the center where the flowers are. Before you stitch a flower, double-check to be sure it is in the desired position. If it has moved, use a long hat pin to reposition it. Poke the point of the pin through a hole in the tulle and use the point to move the flower back into position.

You can stitch through or around every flower and leaf in the design. If you choose to

stitch around a flower, do so right next to the edge of the flower. Do not stitch on the edge of the flower because it may fray the flower. If you want to stitch directly on the flowers and leaves, try to stitch along the indentations. Another possibility is to tack each flower or leaf in the center with transparent thread.

Finish stitching the flowers and leaves in place. Be sure to add stitching to the background area where there are no flowers. Inspect the surface to see that you have enough stitching to hold everything in place. When the stitching is done and the stabilizer is removed, the whole design (background, flowers, and tulle) should act as one fabric. We will refer to this fabric as the *central design*. The stitching on the background where you are just trying to hold the layers together should be no further than 3" apart.

CAUTION: *If it is necessary to fold the fabric piece during stitching, be careful that the pins do not catch on the tulle and tear it.*

14. Remove the tear-away stabilizer (no, you cannot leave it in). It is easiest to tear the stabilizer against the stitching line. Use tweezers to remove the remaining bits of stabilizer.

15. Trim the edges of the central design to square it up. Make sure that any elements that need to remain level (like a table top or vase) are parallel to the bottom edge of the fabric. Centrally located elements must be centered. Use these elements as a reference when cutting the bottom edge. Once the bottom edge is cut, use this as a reference for cutting the sides and the top.

16. Add borders as desired. Layer the central design (with or without borders) with batting and backing fabric. Baste the layers, quilt, and add binding. Below are some quilting designs that fill background areas nicely.

17. Embellish as desired. See "Adding Embellishments" on pages 41–47.

Color and Design

Color Schemes

The colors of the flowers and the color of the background will determine the "flavor" of a quilt. A basic understanding of color schemes will help you successfully select flowers and background fabric.

• MONOCHROMATIC. This is one of the simplest color schemes to use because you basically use only one color. However, to make it more interesting, try using a variety of tints, tones, and shades of the one color to give the design more depth and interest. Bridget Sarosi's bouquet on page 34 is a lovely example of using just yellows.

• COMPLEMENTARY. These are colors found opposite each other on the color wheel. In this scheme, it is best to use more of one color and less of the other. Use the second color as an accent. For example, accent a yellow bouquet with tiny purple flowers.

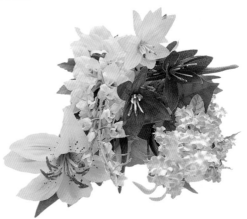

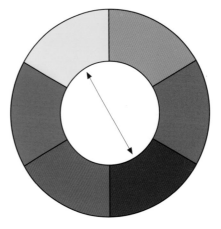

Complementary floral choices

Monochromatic floral choices

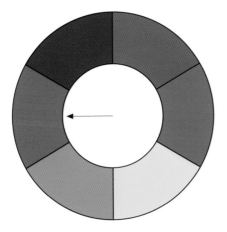

• TRIADIC. The colors in this scheme form a triangle on the color wheel. For example, a bouquet of red, yellow, and blue flowers will make a very nice triadic color-scheme arrangement. Once again, it is best to use the colors in uneven proportions. Kathy Klein's bouquet, shown below (bottom left) is a wonderful example of this color scheme.

• ANALOGOUS. Another color-scheme choice is an analogous color scheme, which uses colors that are next to each other on the color wheel.

Analogous floral choices

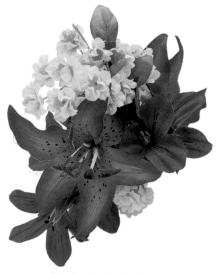

Triadic floral choices

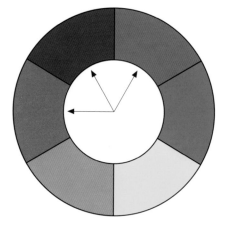

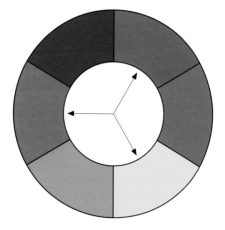

• POLYCHROMATIC. A polychromatic color scheme is my favorite; you can use all of the colors on the color wheel. There is nothing more beautiful than a floral bouquet of lots of different-colored flowers, such as all pastel-colored flowers or all deep-colored flowers.

Polychromatic floral choices

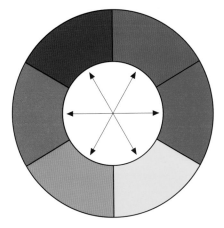

• FABRIC MATCH. Another way to find a color scheme is to purchase a multicolored border fabric first. Use this piece of fabric to select your background fabric and your flower colors. For the quilt shown below, Mary Alice Peeling selected flowers to go with her multicolored border fabric. Once the central design was completed, the border fabric pulled the whole piece together.

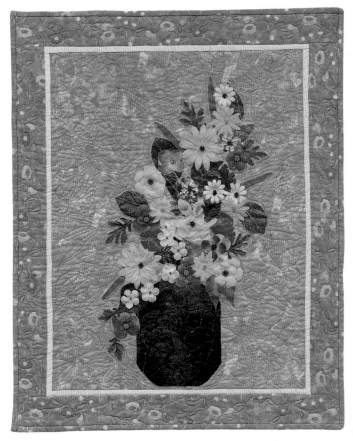

FLORAL STUDY IN BLUE AND YELLOW by Mary Alice Peeling, 2000, Concordville, Pennsylvania, 32½" x 27". This quilt is a still life of yellow, purple, and pink silk flowers with a dark blue batik vase on a light blue background with Tintzl accents and beaded flower centers. Mary Alice Peeling began this project in Maryland at the Mid-Appalachian Quilters' retreat. The flower centers are hand beaded with iridescent dark purple beads, as well as blue, purple, and peach matte-finish beads and yellow glass beads.

Background Fabrics

If you want the flowers to really stand out, there must be some type of contrast between the flowers and the background fabric. It can be contrast in texture, in value, or in color.

Textural Contrast

Stripes, plaids, and checks provide great textural contrast to the gentle curves of flowers. Notice how effective this contrast is between the organically shaped flowers and the geometric background in Kathleen Ventura's quilt.

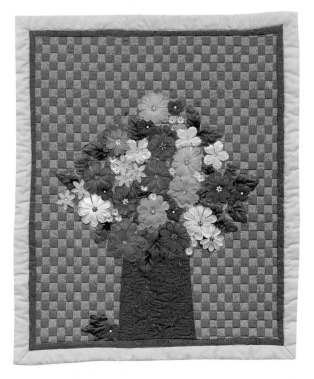

CHECKERED FLORAL by Kathleen Ventura, 2000, Mahwah, New Jersey, 24" x 28". The flower centers are embellished with pearls; flower sequins; and assorted colored, iridescent, and glass beads. The checkered background has a light sprinkling of iridescent Tintzl.

If your background fabric lacks texture, there are many ways to add it. A few simple techniques are mentioned below.

• EMBROIDERING TEXTURAL DETAIL. Use embroidery floss, silk threads, silk ribbons, or any other thread that will add interest. Make a branch with a straight stitch or a chain stitch. Use the featherstitch for things like fern fronds. For more ideas, refer to a book on embroidery stitches.

• DRIZZLING THREAD (example 1 at right). One of the simplest ways to add texture to a background is to drizzle some thread on the background fabric. If done in green thread, this will resemble the greenery that is often added as filler to bouquets. Look at Sampler Block 9 (page 58) to see the effect of drizzling metallic thread on the background.

• ADDING TINTZL (example 2 at right). This product is similar to tinsel used on Christmas trees (see description on page 10). It will add an element of sparkle to any design. To see an example of Tintzl in use, refer to Sampler Blocks 1, 3, and 4 (pages 52–55). To add Tintzl, pull a few strands from the bag and lay them on the background fabric *after* positioning the flowers and *before* layering the tulle on top. If you put the Tintzl on before positioning the flowers, it will stick to the flowers and leaves as you try to reposition the design. You can use several different colors of Tintzl in the background and in the flower design.

• ADDING CUT FABRICS (example 3 at right). Cut fabrics will also add texture to the background. Randomly cut pieces of green cotton will give the impression of greenery. Use sheer fabrics to give a subtle illusion of greenery. Once cut, place the fabrics on the background fabric first; then position the flowers and leaves.

• STITCHING GREENERY (example 4 at right). The small branches of leaves on Sampler Block 5 (page 55) were stitched on the background before adding the flowers. You can create greenery with straight stitching or free-motion stitching. You can also use some of the wonderful decorative stitches that are available on some sewing machines.

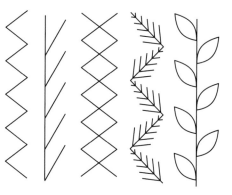

Here are a few pointers for stitching greenery with your sewing machine.

• Lock the stitches at the beginning and end of the stitching line.

• Decorative stitches are often directional and can usually be flipped over or reversed. Be sure the design is pointed in the direction it would grow on a branch.

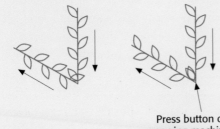

Press button on sewing machine to reverse direction of the stitch.

• To make the greenery look more realistic, overlap and intersect stems with one another.

• Use a variety of different thread weights and colors to add interest. If you use a heavier thread, use a larger sewing-machine needle.

• Always use tear-away stabilizer underneath the background fabric, which will help keep the fabric flat and make the stitches look better.

• If you need a reference line to guide your stitching, use an air-erasable marking pen to sketch some lines.

• USING PERMANENT MARKING PENS (example 5 below). An even faster way to add greenery is to use a permanent fabric marking pen. Pigma pens come in many different colors and a couple of different thicknesses. Draw stems, leaves, and/or ferns directly on the background fabric.

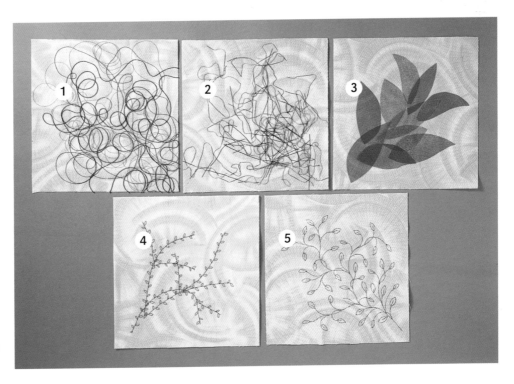

Examples of texture:
1) drizzled thread,
2) Tintzl, 3) cut sheer fabrics, 4) decorative machine- stitched branches, and
5) branch lines drawn with a Pigma pen.

Value Contrast

Look at the quilts on this page to see how contrast in value helps the flowers and leaves stand out from the background. Julie A. Liggett placed dark flowers on a light background, while Debra Lynn-Weigand did the opposite, placing light flowers on a dark background. Monica Cespino-Dowd placed dark leaves on a light background.

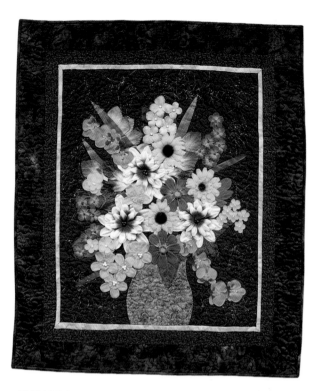

FLOWERS FOR ANY OCCASION by Debra Lynn-Wiegand, 2000, North Wales, Pennsylvania, 30" x 35". Tintzl in the background adds glitz, and a layer of black tulle covers the design. The vibrant colors brighten up Debra's home, and this quilt reminds her of her grandmother's love for flowers.

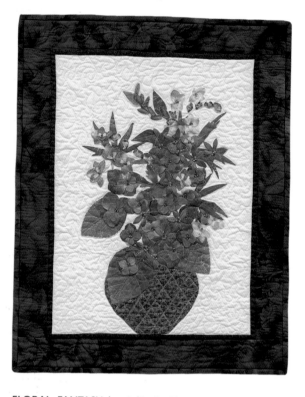

FLORAL FANTASY by Julie A. Liggett, 2000, Melrose Park, Pennsylvania, 28½" x 23". Claret, peach, and dark blue flowers are layered on cream fabric that resembles cracked ice. A dark gray patterned vase holds the arrangement of flowers. Tintzl, drizzled onto the background before the layer of cream tulle was applied, adds highlights to the design.

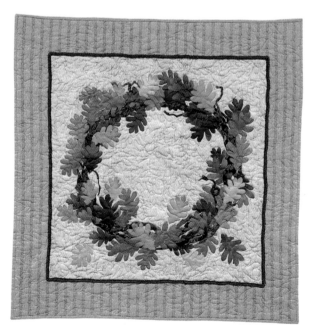

AUTUMN by Monica Cespino-Dowd, 2000, Staten Island, New York, 39" x 39". Twisted branches and autumn leaves create a festive wreath.

Color Contrast

Contrast in color is easy to achieve by simply using opposite colors on the color wheel. The yellow flowers are striking on the blue background in "Bouquet of Sunshine," shown on page 30.

Keep in mind that warm colors like yellows, reds, and oranges will appear to come forward and are good choices for flowers. Cool colors like blues, greens, and violets appear to recede and therefore work well for backgrounds. If you are having difficulty deciding on a color for the background, try sky blue; it works beautifully behind almost any flower and Mother Nature chooses it for her background, too. Also consider using a plain piece of fabric or a pieced design. Barbara J. Broshous created a dramatic pieced design for the background of her bouquet quilt "Floral Flair," shown below.

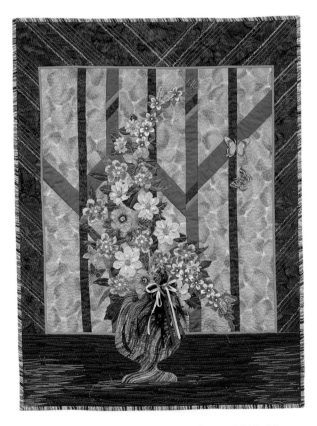

FLORAL FLAIR by Barbara J. Broshous, 2000, Monument, Colorado, 34" x 45". Created in a workshop for the Colorado Quilting Council, the geometric pieced background creates a lovely contrast for a crescent-shaped bouquet. Yellow flower centers are made with scrunched rickrack. The ribbon bow and butterfly motifs cut from fabric are attached to the design on top of the tulle.

Floral Bouquets

There are many types of designs you can create with flowers, and a variety of background fabrics to go with them. Let's talk specifically about selecting a background fabric for a bouquet of flowers. Do you want your bouquet to look like it's sitting in a wallpapered room? If so, you can select a fabric that looks like a wallpaper design.

If you want your bouquet to look like it's sitting on a table, add a background fabric that resembles a table or a colorful tablecloth. The edges of the table can be parallel to the bottom edge of the quilt or at an angle as seen in Dee Houston's bouquet "Floral Vase," shown below.

Placing your bouquet on a sky blue design or dark leafy print will give the appearance that your bouquet is outdoors. The possibilities for backgrounds are endless. Experiment with several background fabrics to see what looks best with the colors you have chosen for your flowers.

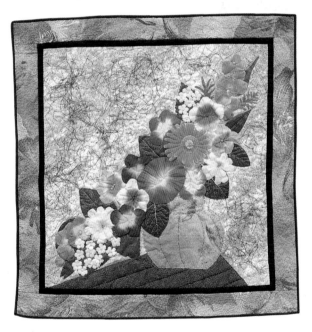

FLORAL VASE I by Dee Houston, 2000, Hyattsville, Maryland, 30" x 30". Dee began this piece during a workshop at the Mid-Appalachian Quilters' retreat. The arrangement of the vase and table is inspired by the works of Matisse. The flowers flow along a diagonal line bisecting the central design. The background, vase, and border fabrics are all upholstery fabrics, chosen for their blended colors with glints of gold.

Flower Positioning

Whether you create a simple botanical print of your favorite flower or a complex bouquet, the placement of the flowers will help produce a visually pleasing design.

Large flowers can stand beautifully all alone (block 1 below). However, if they do appear on a branch or a stem or in a vase, they should be positioned so that they do not appear too heavy. In a bouquet, for example, they look most balanced if positioned close to the vase.

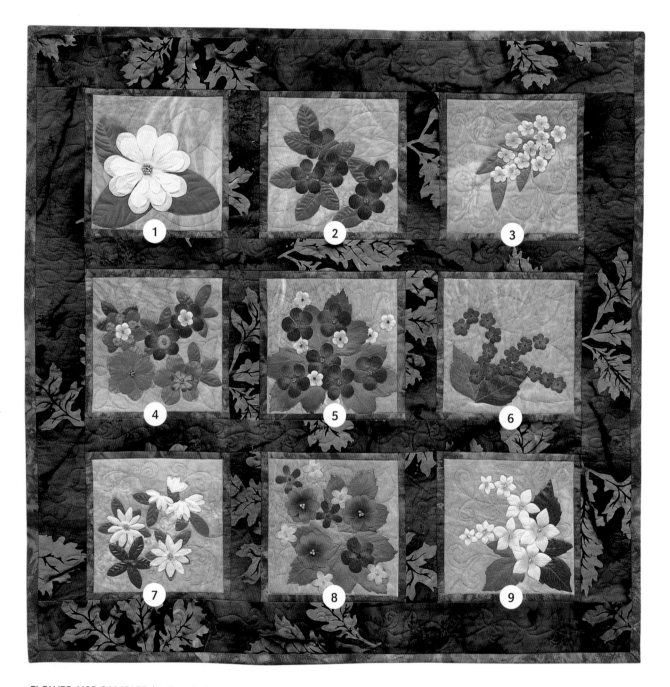

FLOWER USE SAMPLER by Bonnie Lyn McCaffery, 2000, Hawley, Pennsylvania, 37" x 37". Examples of arranging flowers (from left to right and top to bottom): 1) single flower, 2) overlapping flowers for dimension, 3) clusters, 4) combination of different flowers, 5) scattered flowers, 6) lines of flowers, 7) folded flowers, 8) leaves to help flowers stand out, and 9) lines of flowers in graduating sizes.

Smaller flowers can be scattered alone (block 5 at left), grouped in clusters (block 3 at left), or assembled in a line (block 6 at left). For example, lilacs are simply clusters of tiny flowers. Look at the flowers before you remove them from the stems. Consider how they are positioned on the stems. Are they clustered? Or do they perhaps extend in a linear pattern along the stem? The size of the flowers may even be graduated, from large to small as they move up the stem (block 9 at left).

Single-layer flowers and leaves can be folded in half or in quarters to give the appearance of being viewed from the side (block 7 at left). To fold a flower, press it with an iron to hold the fold.

CAUTION: *Protect the iron and ironing surface by positioning a piece of paper over and under the flower or leaf. If the flower or leaf still needs help to hold the fold, use a small-headed pin to temporarily hold the flower until the tulle is added. Once the tulle is placed on top, pull the head of the pin through the holes in the tulle.*

While it is good to note how flowers grow on the stem, you do not have to re-create them exactly as they exist in nature. Why not create your own variety by placing a small flower in the center of a large flower (block 4 at left)?

Don't forget to overlap some of your flowers (block 2 at left). Overlapping gives the design a more realistic dimension. Keep in mind that warmer, lighter, and brighter colors tend to come forward. If you have two overlapping flowers, it works best visually if the warmer or lighter flower is on top of the cooler or darker flower.

Leaves are helpful in making some colored flowers stand out. Light flowers on a light background might blend so much that the flowers are barely visible. Placing a dark leaf under a light flower will provide contrast between the flower and the background and help the flower stand out (block 8 at left).

Leaves

Once you start looking at silk flowers, you'll notice that there are many different types of leaves. While most flowers come with leaves attached, there is no

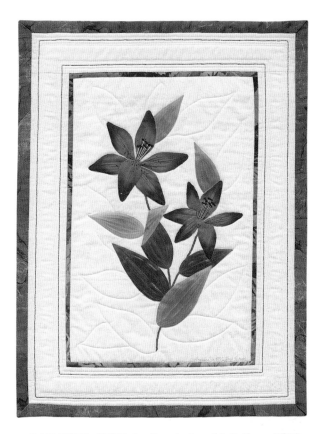

BOTANICAL PRINT by Bonnie Lyn McCaffery, 2000, Hawley, Pennsylvania, 19" x 25". A single stem of blue tiger lilies was used to create this botanical print. Dark blue YLI Candlelight Yarn is couched in the border for an added touch to the frame.

Wide variety of leaf shapes and colors

rule that says you have to use the flowers and leaves together; feel free to mix flowers and leaves. Look at the size, the color, and the shape of the leaves to determine where they can be used to their best advantage. Leaves can be used to fill the areas between flowers. And they can also act as connectors between flowers instead of using stems. It is possible to do an entire bouquet without adding any stems. Long, thin leaves are perfect for connecting flowers of graduating sizes in a line.

Connections

It is important in most of the floral designs that the flowers are visually connected to each other. One way to connect the flowers is to overlap them so that the stems appear to be hidden behind the flowers. Another way is to position long slender leaves behind the flowers so that the flowers appear to be

growing from the same plant. A third way to visually connect flowers is to add stems to the arrangement.

Stems can be created several different ways. Long, thin shapes can be cut from fabric. Silk ribbons make nice straight stems. Clover Quick Bias Tape can be pressed on the background fabric to create gently curving stems. This method requires some preplanning because the stems need to be ironed to the background fabric prior to placing the flowers. For stems that are more realistic, use the "Twisted Branches" technique on facing page.

Finally, it is possible to give the appearance of connection just by placing flowers in line or in a cluster without actually having them touch each other. To make this option successful, it is important to use several flowers and position them close enough to each other so that they appear to have a visual connection.

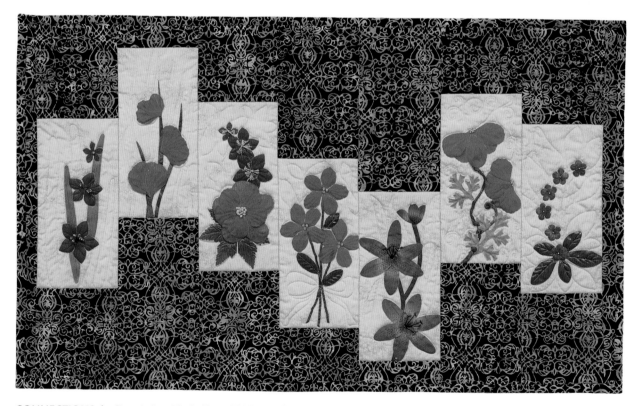

CONNECTIONS by Bonnie Lyn McCaffery, 2000, Hawley, Pennsylvania, 26" x 21½". The flowers in this quilt appear to have a visual connection by using a variety of different techniques. From left to right: long, thin leaves behind flowers; long, thin shapes cut from fabric; flowers touching and overlapping; silk ribbon stems; Clover Quick Bias Tape stems; twisted branch technique; and flowers positioned to appear to have a visual connection without actually touching.

Twisted Branches

This simple technique lets you add realistic-looking branches to scenery, bouquets, and other fantasy floral quilts.

Branch Materials

Any type of fabric that can be twisted can be used for branches. The fabric should be soft and twist easily, and it should not be too thick because this creates bulky branches. Cottons, suede cloths, polyester-cotton blends, and stretch knits are just a few fabric possibilities. When searching for the perfect branch fabric, look for one where the color on both sides of the fabric will be appropriate for the branches. Some colored cottons are printed on a white fabric. For example, the light brown fabric shown in the photo at top right will not work as nicely for branches because as you twist the fabric, the white side will show.

Silk ribbons work beautifully for thin branches. Ribbons come in various widths and the narrower widths produce exceptionally thin branches. Use a wider ribbon to create thicker branches. If you can't find wide ribbons, layer two or three strands of a narrow ribbon to create a thicker branch. Silk ribbon is available in solid colors, hand-dyed colors, and sheer organdy.

Decorative threads and yarns can be added to the branch fabric as it is twisted to add another element of texture. For example, metallic threads and YLI Candlelight Metallic Yarn add interesting texture to branches.

Making Twisted Branches

To begin, think about how a branch looks. The end of a branch is usually narrow and becomes thicker as it joins into another branch. This process continues down to the base of the tree, where all branches come together to form a wide trunk. The twisted branches are created in this same manner.

1. Cut several 1"-wide strips across the width of the branch fabric; remove the selvage ends. The 1" width is an arbitrary measurement; you

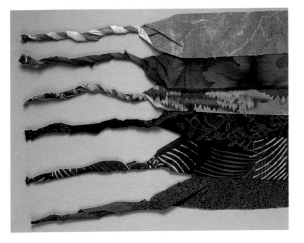

Both sides of the branch fabric will be visible. The light brown fabric at top is not a good choice because the back of the fabric is white.

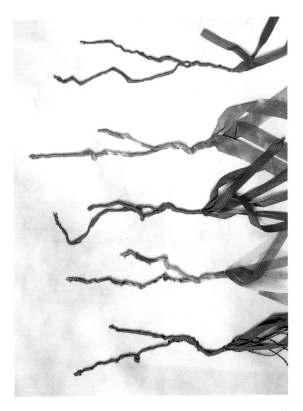

Top to bottom: YLI Silk Ribbons, YLI Hand Dyed Silk Ribbon, mixed ribbons, YLI Spark Organdy Ribbon, and YLI Candlelight Metallic Yarn with YLI Silk Ribbons.

may want to experiment with other widths. Another option is to tear the fabric into strips. The torn strips have slightly frayed edges that add a different texture to the branches.

2. Place the background fabric on top of a piece of tear-away stabilizer, which will keep the fabric flat while pinning branches to it.

3. Pinch and twist the end of a strip of fabric. Damp fingertips will help get the twist started. Pin the twisted tip to the background fabric and stabilizer.

4. Twist the fabric strip for about 4" to 5". Twist tightly enough so that the strip begins to twist back on itself. Before you pin the branch in place, note which direction you twisted the fabric strip. It is important that all branch strips are twisted in the same direction. (When you are ready to twist 2 branches together, one of the branches will untwist if both branches are not twisted in the same direction.) Pin the twisted branch to the background fabric and stabilizer. Leave the untwisted portion of the fabric strip on the background fabric.

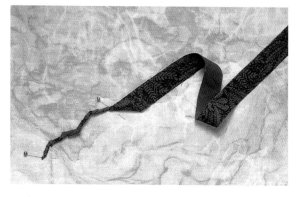

Start to twist the branch fabric and pin at the beginning. Pin again where it will intersect with another branch.

5. Twist and pin a second fabric strip to the background fabric and stabilizer. Pin the tip somewhere near the tip of the first branch. Twist this second strip until it starts to twist back on itself. Hold it next to the first branch to see if it looks the way you want it to. It may need more twisting if it is not long enough. Allow the branch to curve toward the first branch rather than pulling it straight. After the second branch is twisted about 4" to 5", and it lies the way you want, connect and pin it to the first branch at the second pin.

6. Now hold the 2 strips of fabric together and twist them as one branch. Twist for about 4" to 5", until you start to see distortion. Pin the branch to the background fabric and stabilizer.

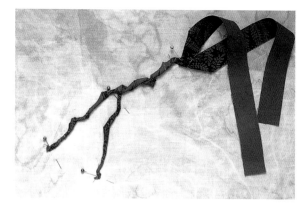

Twist a second branch. At the point where it meets the first branch, begin to twist the two strips together.

7. Add a third and fourth branch in the same manner described in steps 5 and 6.

8. Go to another area of the central design and start a completely new branch. Create this the same way you created the first set of branches. When this set of branches meets the first set of branches, twist all of the fabrics together to make a thicker branch. Continue to create branches until the desired area is filled. Allow the branches to cross occasionally for a more realistic look.

9. On the sewing machine, bartack the point where each pin was placed. If the branches are dark, use a transparent thread in the color smoke and a small satin stitch. To speed up the

process, do not cut the thread before tacking at each point. Just move to the next place and stitch.

Once all places have been tacked, remove the project from the sewing machine and cut the excess top thread and bobbin thread.

10. Add flowers and leaves to the branches. Then pin a piece of tulle on top. Take care that there are no pleats in the tulle. The tulle has a slight amount of stretch that will allow it to conform to the branches.

11. Stitch the layers together as described in "The Basic Steps" on pages 13–16. You can stitch through the thinner branches if necessary, but stitch a little slower when stitching through several layers of fabric. Stitch around the thicker branches, placing stitches as close to them as the sewing-machine foot will allow.

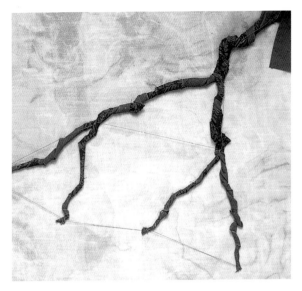

Tack at each point where a pin holds the branch. There is no need to cut the threads between the points until all of the points have been tacked.

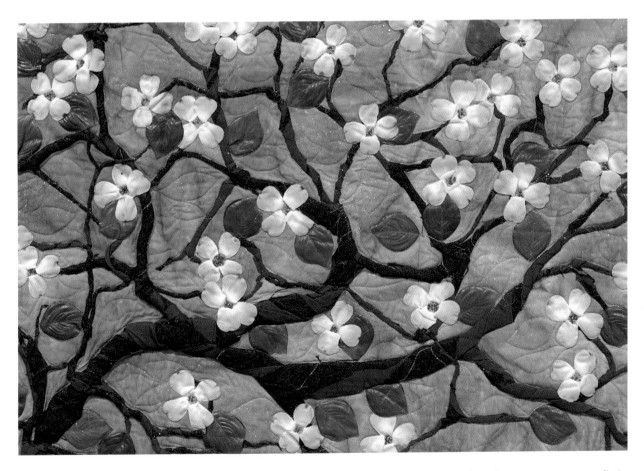

GRANDMOTHER'S DOGWOOD detail; see page 7 for full quilt. Use the twisted branch technique to create realistic shading and dimension.

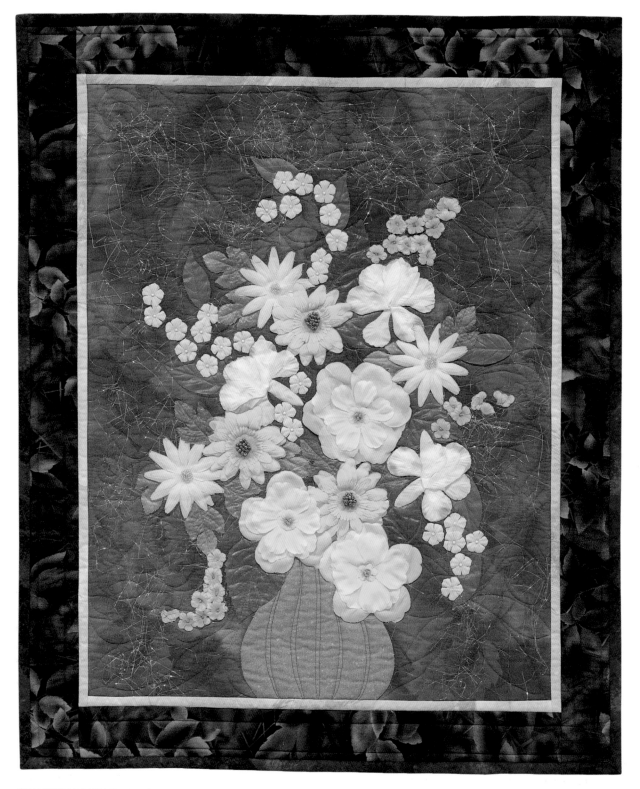

BOUQUET OF SUNSHINE by Bonnie Lyn McCaffery, 1999, Hawley, Pennsylvania, 27½" x 33½". A layer of green tulle tops yellow flowers and Tintzl on a blue green background.

Bouquet Quilts

Containers

If you decide to arrange your flowers in a bouquet, you will need to place them in a container. There are many styles and shapes to consider for your bouquet. The fabric as well as the shape will help convey a realistic container.

If you are going to make your container from cotton fabric, spray starch and press the fabric before cutting to give the fabric more body. If the

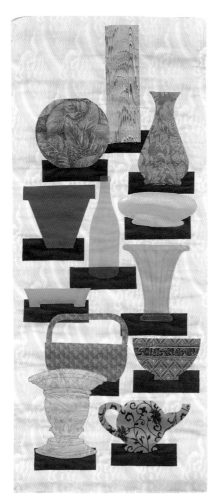

Various fabrics and shapes can be used to create realistic-looking containers. Here are some suggestions, shown from top to bottom and left to right: marbleized fabric rectangle, cotton-print round vase, brocade vase, suede-cloth flower pot, colored-vinyl wine bottle, gold lamé container, olive green satin container, pink vinyl "crystal" vase, cotton-print basket, cotton-print bowl, marble fabric "stone" vase, and satin-print teapot.

fabric is not cotton, be sure that it does not fray easily. The cut edge will be somewhat protected by the tulle that is placed on top, but it will not keep a quick-fraying fabric from fraying.

It is a lot of fun (and extremely easy) to create your own container. Follow these simple steps.

1. Fold a piece of paper in half (lengthwise or horizontal depending on the type of vase you would like to make).
2. Sketch a design on the folded piece of paper, keeping in mind that the paper will be unfolded to create a symmetrical vase. The most important thing to remember is that the bottom of the vase should be flat.
3. With the paper still folded in half, cut out the design.
4. Open the paper up and see how the design looks. The odds are that the design will be too wide. Refold the paper and trim a little more.

NOTE: *Sketching a design beforehand is not necessary unless you feel more comfortable doing so. You can just cut your vase shape directly from the paper. It is, after all, only paper; if you're not happy with the first vase, grab another piece of paper and try again.*

5. Once you have a vase that you think may work, lay it on the background fabric. Try to visualize flowers in it. How large will your bouquet be? Will there be enough air space around the flowers? Does the vase seem too large or too small? A simple guideline to remember is that a vase should be no more than one-quarter to one-third of the height of the background fabric. Now is the time to modify the size and shape of the vase while you are working with paper.
6. Use the pattern to cut out your vase from fabric. Pin the pattern to the fabric with enough pins to hold it in place. If pins will leave holes in your fabric, do not use them. Instead, place the pattern on top of the fabric and carefully draw around the shape with a marking pen. Cut the vase with sharp scissors; you want a clean-cut edge.

7. Center the vase toward the bottom edge of the background fabric. Use a ruler to be certain that the vase is centered. If the vase is off center even slightly, your error will be visible. If you choose to position your vase off center, it must look intentional. Move the vase up about ½" from the bottom edge of the background fabric to allow for the seam allowance.

Symmetrical or Asymmetrical Designs

Bouquets can be arranged symmetrically or asymmetrically. Bouquets that are symmetrical will have the same shape on opposite sides. Having the same shape on opposite sides does not mean that the flowers must be arranged symmetrically; in fact, it will be more interesting if they are not. It just means that the overall shape should be the same on opposite sides. The arrangement of flowers and color should look balanced. Take time to look at each flower and color separately. Decide whether a particular flower or color has been evenly distributed throughout the bouquet.

Bouquets that are asymmetrical will not be the same on opposite sides. They are considered more contemporary in design, but the arrangement must still have visual balance. Position larger flowers closer to the bottom of the arrangement or the vase. Strive to make the arrangement look like the flowers could actually balance on the edge of the vase. A good example of an asymmetrical design is Laura M. Orben's wonderful bonsai tree shown below left.

Round Arrangements

Among the more popular designs are oval or round arrangements (see bouquet style 4 on page 33). A beautiful example is seen in Elaine M. Reuschlein's quilt "Aunt Margie's Bouquet." The container is centered at the base of the arrangement and the flowers extend in a symmetrical round shape above the container.

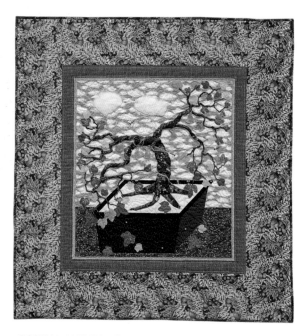

BONSAI AUTUMN by Laura M. Orben, 2000, Milford, Pennsylvania, 37" x 39". The inspiration for this quilt came from seeing the twisted branch technique, which reminded Laura of very old, twisted branches of some bonsai trees. Small maple leaves in fall colors led to the name "Bonsai Autumn." Golden tassels, braiding, and some cute little dragonflies reflect the Asian theme. Crystal sequins and iridescent icicles create the effect of snow and ice falling from the sky. Of course, all this snow and ice falls from clouds, which she made out of Halloween spiderweb material.

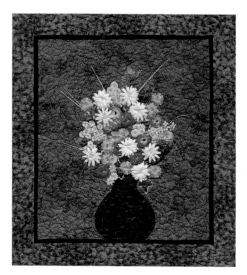

AUNT MARGIE'S BOUQUET by Elaine M. Reuschlein, 2000, Cumberland, Maryland, 25" x 28". A rainbow of silk flowers forms a circular bouquet on a purple marbled background. The bouquet is drizzled with iridescent Tintzl, and the background has purple Tintzl scattered over it. Black tulle on top enhances the colors of the design. Beads are in the center of each flower. Elaine made this bouquet with Home Interior flowers for her Aunt Margie, who sells the same flowers.

Triangular Arrangements

Triangles are another popular design in flower arrangements. Flowers can be arranged in triangular shapes to create either symmetrical or asymmetrical designs.

An equilateral triangle design is a symmetrical arrangement because all three sides of the triangle are equal in length (see bouquet style 1 at right). When positioning the flowers in the triangle, center an element close to the top to create a visual point. Then extend a single element to each side to create a visual point at the left and the right. You can create these visual points with a leaf or with a line of flowers. This should not be an actual line of flowers going up the edge of the triangle but an imaginary line to which the flowers extend. Once the three points of the triangle are established, fill the remaining area of the triangle with flowers. To create a taller triangle, consider an isosceles triangle where the two sides are equal in length but the base is shorter than the sides (see bouquet style 2 at right).

A right triangle can be used to create yet another style of bouquet (see bouquet style 3 at right). Position the base of the triangle parallel to the bottom edge of the quilt and one side perpendicular to the bottom edge. Flowers in this arrangement will be asymmetrical. In order for the design to feel balanced, it may be necessary to move the bouquet off center, with the perpendicular edge closer to the vase edge.

A more contemporary version of the triangle is one that is created with sides that are not equal in length and no right angle (see bouquet style 5 at right). This narrow triangular shape works well with a tall, thin container.

Rectangular Arrangements

A rectangle can be used as the basis of a floral arrangement and can be positioned vertically or horizontally. A vertical rectangular design—a simple arrangement that requires very few flowers—needs a tall, thin container (see bouquet style 10 at right). A horizontal arrangement will look better in a low, wide container (see bouquet style 8 at right).

Bouquet styles from top to bottom: 1) equilateral triangle, 2) isosceles triangle, 3) right triangle, 4) round, 5) narrow triangle, 6) crescent, 7) fan shape, 8) horizontal rectangle, 9) S curve, and 10) vertical rectangle.

Radiating Arrangements

The fan-shaped arrangement is another popular floral design that is very balanced and symmetrical (see bouquet style 7 above). The container should be carefully centered below the fan of flowers. All elements of this design should radiate out from the center of the container.

Curved Arrangements

The curved shape can be used to create some unusual arrangements. Try a crescent moon shape balanced over a container (see bouquet style 6 on page 33), or a gentle S curve above and below the container (see bouquet style 9 on page 33). If you need a visual guide for placing the flowers, sketch the shape with an air-erasable marking pen on the background fabric before arranging the flowers. Bridget Sarosi did a beautiful S-curve bouquet.

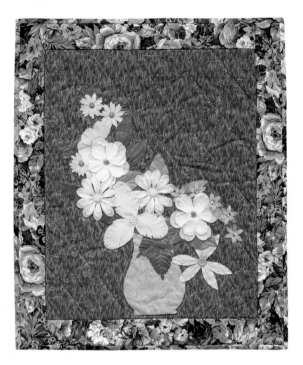

SPRING BOUQUET by Bridget Sarosi, 2000, Johnstown, Pennsylvania, 25" x 29". This wall hanging is a spring bouquet of monochromatic yellow flowers arranged in an S-curve design. Beads and buttons embellish the flower centers to add dimension. The Tintzl, sandwiched between the quilt top and tulle, adds the sparkle.

Landscapes

Flowers and landscapes are a natural mix. Flowers can be added as elements viewed up close and incorporated into a scene as I did in "Wildflowers" on the facing page.

The most important thing to remember when creating a landscape is perspective, and there are three things to keep in mind when trying to create the illusion of perspective.

The first element to consider is the size of the flowers. Small flowers appear to be farther away than larger flowers. Very large flowers appear to be very close to the viewer. Overlapping the flowers also gives your design depth; place larger flowers over the edges of smaller flowers.

The second element is the color of the flowers. As with size, color is helpful in creating depth. Warm colors like red, yellow, and orange appear to be closer than cool colors such as green and blue. And bright colors appear to be closer than muted colors. When choosing flowers, consider these color characteristics as well as the size of the flowers. For example, warm, bright flowers should be larger than cool, muted flowers.

The third element to think about is the positioning of the flowers. Near the bottom of the design, place flowers that you want to appear close. The flowers should decrease in size as they move upward on the design surface.

One way to make your scene appear to go on forever is to have the flowers violate the edges. When the border is added, square off the edge of the central design and don't be afraid to cut off parts of a petal. The viewer will believe that there is more to this scene and he or she is just getting a small view of it.

WILDFLOWERS by Bonnie Lyn McCaffery, 2000, Hawley, Pennsylvania, 40½" x 30½". A twisted branch extends over a landscape.

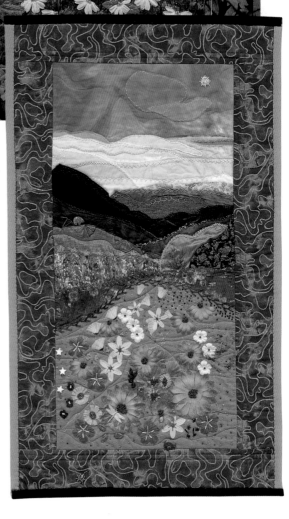

CELEBRATING SEPTEMBER by Patti Shreiner, 2001, Shohola, Pennsylvania, 19½" x 32¼". This quilt was inspired by the beautiful landscapes surrounding Patti's cabin in the Poconos, during the transition of the seasons. Created without a pattern, this small landscape was cut freehand using twenty-seven different fabrics, including cotton, silk, wool, rayon, denim, and polyester. More than forty different threads and YLI Silk Ribbons were used with twenty-two different embroidery stitches. Hard embellishments include charms, a goldstone bear, mother-of-pearl stars, amethyst beads, glass leaves, a fossil snail, and a variety of smaller beads including the letter "E," drop, bugle, seed and pansy.

The background fabric is very important in making the design look like a scene. Think about where the flowers might actually appear in nature. For example, it might be a mottled brown forest floor or a grassy field. There are some wonderful textured prints inspired by nature that are available. Select your fabric carefully.

You may also choose to incorporate other things into the landscape. Keep in mind the lessons of size and placement of items. A barn in the distance should be placed above the large flowers at the bottom of the design. The barn will also need to be smaller so that it appears to be in the distance. Animals, bugs, birds, buildings, and a bird's nest are just a few things that could be added to the scene. These can be cut directly from novelty prints if you are lucky enough to find the perfect size and motif in a printed fabric. Remember that the edges will not need to be turned under or stitched because they will be captured under the tulle.

Before you begin to create your landscape, I encourage you to look in garden books and magazines. Notice where flowers are located in a scene. How does the size and placement of the flowers in the photograph make the picture appear to have depth? You may want to find a photograph of a landscape to use for inspiration. Keep it simple and eliminate any complex details. And most of all, have fun!

Silk-Flower Color Play

Another way to experiment with silk flowers is to think of them not as flowers but as areas of color. You can then "paint" with the flowers.

There are two different ways to do this technique. The first is to select a group of flowers you like. Disassemble the flowers and iron them with a medium temperature iron so that the flowers lie flat. Don't forget to protect the iron and ironing surface as described on page 14. Then select a background fabric. A solid or solid-looking fabric will work better the first time you experiment with this type of design. Lay the background fabric on a piece of tear-away stabilizer. Now the fun begins. Just play with the flowers. Try using them to create areas of color, lines of color, or gradation of color.

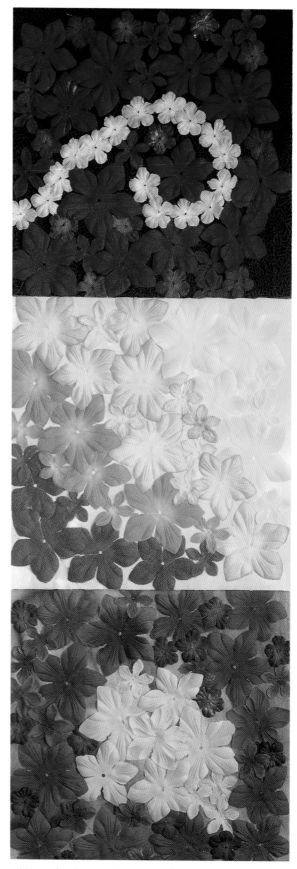

Lines of color, gradation of color, and areas of color

Please note that it is unnecessary to cover the entire background fabric.

The second way to "paint" with flowers is similar to the first technique, but this one requires that you make a sketch of an abstract design to use as a reference (see sample art at right). Using colors similar to the flowers you want to use, play with crayons and markers to sketch areas of color. Any lines on the abstract sketch should be fairly wide because they will be translated into a line of flowers or leaves. Now, play with the flowers and leaves, but use your sketch as a reference.

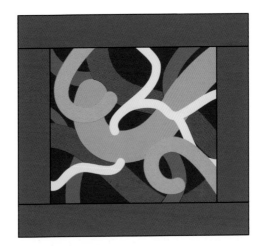

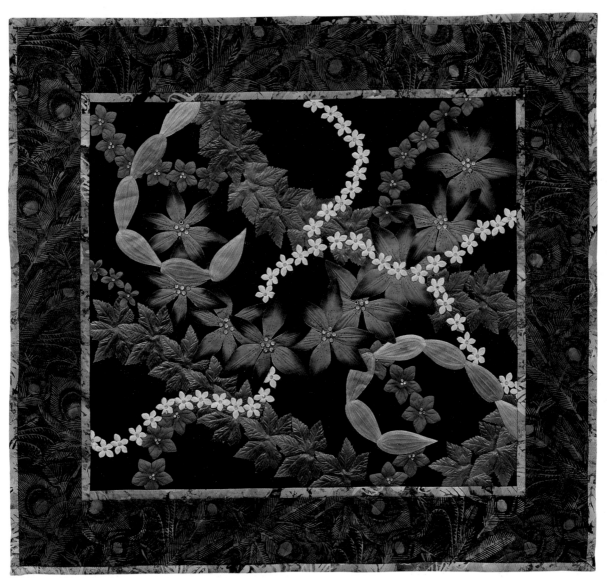

COLOR PLAY by Bonnie Lyn McCaffery, 2000, Hawley, Pennsylvania, 36" x 33". Dark blue tiger lilies, blue delphiniums, and yellow delphiniums dance on the surface of this quilt. The flower centers are embellished with iron-on rhinestones.

Silk-flower color play can also be done in a more organized fashion. The half kaleidoscope image shown below was created by dividing a half circle into wedges with an air-erasable marking pen. The marks were used as a reference for creating lines and areas of color with flowers. Once arranged, the flowers and leaves were glued in place with Fabri-Tac.

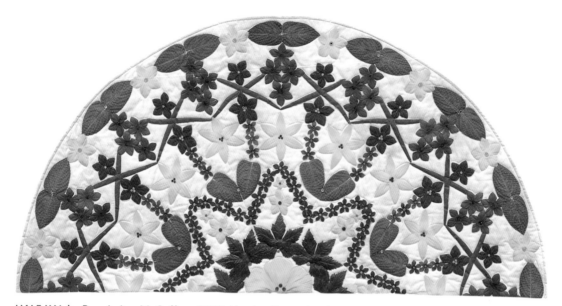

HALF KAL by Bonnie Lyn McCaffery, 2000, Hawley, Pennsylvania, 42" x 21". The flowers are used as color, shape, and line in this half kaleidoscope. Iron-on rhinestones add embellishment.

Silk Flowers on Clothing

Once you master the technique for "painting" with flowers (and it won't take long), you may want to try adding silk flowers to clothing.

Careful thought must be given when considering to use silk flowers on clothing. First, you must be sure that the items will be able to withstand the stress of being worn. Second, the items captured may or may not be able to be laundered. Be certain that all items can be laundered or cleaned in the same way. Metallic items like Tintzl and metallic stars cannot be dry-cleaned because the process dulls metallics, but they can be gently washed by hand.

Flowers are made of so many different materials that it is advisable that you make a small test sample of the flowers you want to incorporate. Try

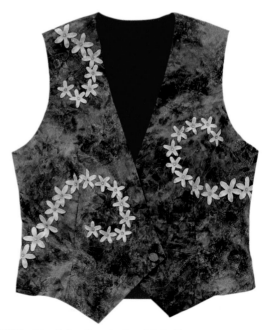

VEST, side 1, by Bonnie Lyn McCaffery, 2000, Hawley, Pennsylvania. Simple lines of flowers are attached to batiks. The flower centers are embellished with iron-on rhinestones.

gently hand washing them to make sure that they will hold up. If they don't, save the flowers for a wall hanging that will not need to be laundered.

As you make decisions on placement of the flowers, consider placing them in areas that will not get a lot of abuse. If you always carry your purse over your left shoulder, you may want to avoid adding flowers to that area.

Design Tips

Choose a pattern. A vest is a great first item. Use the drawings that come in the pattern to test design possibilities and ideas. Make quick thumbnail sketches and do not go into great detail; just scribble some circles for flowers and ovals for leaves.

The design you choose can be lines or clusters of flowers, or it could even be an entire garden scene along the bottom edge of the vest. Make several tracings of the clothing pattern and experiment with many possibilities until you find one you like.

If you want a design to extend onto the back of the vest, consider allowing it to travel across the top of a shoulder or around the side seam to the back. Think carefully about which back shoulder seam or side seam will attach to the front of the vest, since this information will determine flower placement.

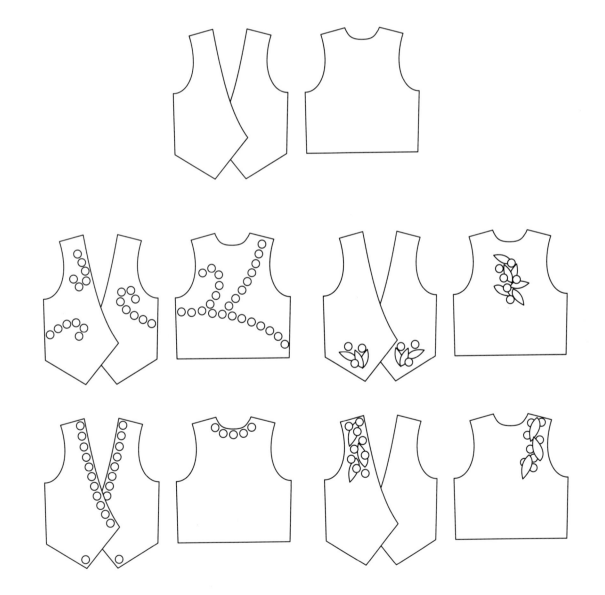

Sewing

1. Cut the fabric pieces using the pattern. Mark any darts with an air-erasable marking pen.

2. Lay the cut fabric pieces, right side up, on pieces of tear-away stabilizer that are a little larger than the fabric pieces. Now begin laying out the flower design. Use your drawing as a reference, but don't hesitate to make changes as you become inspired by the creation. If your design flows from the front to the back, mark corresponding reference points on the front and back pieces. Measure the distance from the same edge (for example, sleeve edge or bottom edge). Be careful to note which front shoulder will be stitched to which back shoulder, and which side seams go together. Do not place flowers within the ⅝" seam allowance and the darts. You can create a visual line of flowers across the shoulders or side seams, but they should not be stitched into the seams.

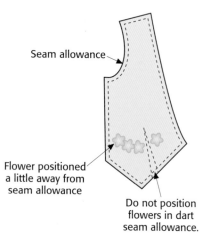

Seam allowance

Flower positioned
a little away from
seam allowance

Do not position
flowers in dart
seam allowance.

3. Once all the flowers are in position, add the top layer of tulle, pin, and stitch the layers together. Add more stitching than necessary to hold the layers together. To minimize bulk, I do not add backing and batting, and I do not quilt the vest.

4. Remove the tear-away stabilizer. Trim the tulle to the edges of the fabric pieces. Assemble the vest following the pattern instructions.

It is also possible to add areas of flowers without covering the entire vest in tulle. Follow the directions at left, but create only one area of flowers. Cover the area of flowers with a piece of tulle slightly larger than the area. Pin the layers together and stitch an initial line around the area of flowers with transparent thread. Then stitch around or through the individual flowers to hold them in place. Do not stitch outside the initial line of stitching. Trim the excess tulle close to the initial line of stitching. Add a line of zigzag stitching over the cut edge of tulle to reinforce the edge. Continue to assemble the vest as described in step 4 at left and in the pattern instructions.

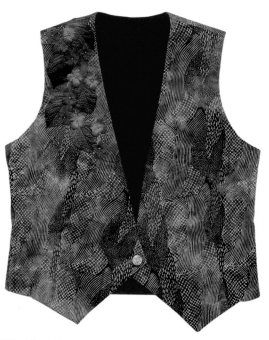

VEST, side 2, by Bonnie Lyn McCaffery, 2000, Hawley, Pennsylvania.

Adding Embellishments

ONCE YOU COMPLETE THE QUILT TOP, it is time to think about how you want to embellish your quilt. Soft embellishments like embroidery can be done before quilting. Hard embellishments, like rhinestones and beads, should be done after quilting. Otherwise the beads will interfere with the darning foot or free-motion embroidery foot during the quilting.

The flower centers will need the most attention. You may also want to add some other embellishments to the design itself. Butterflies and bugs are just a few ideas. Kathy Klein added resin ladybugs and butterfly pins on top of the tulle in her quilt shown on page 42.

Sue C. Powell created dragonflies with her embroidery machine and then cut them out and added them to the surface of her quilt, shown below and in the detail photos on pages 2 and 3.

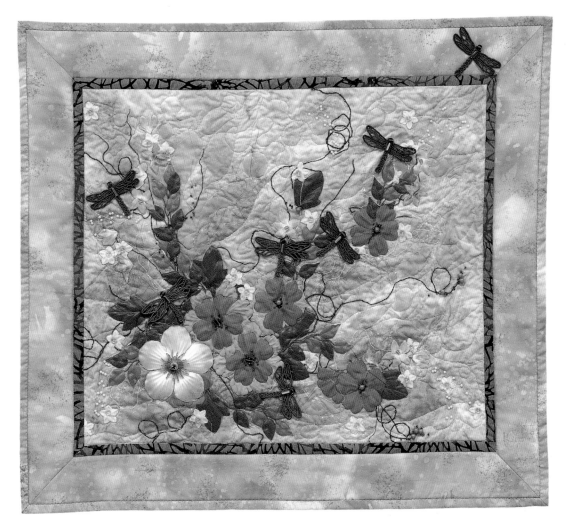

DRAGONFLIES IN MY GARDEN by Sue C. Powell, 2000, Halethorpe, Maryland, 23½" x 26". This quilt incorporates pieces of yellow, green, and lavender tulle; Tintzl; beads; feathers; YLI Candlelight Metallic Yarn; silk flowers; and leaves, all under a layer of pale lavender tulle. Beads highlight the flower centers and other points on the quilt. The freestanding dragonflies were made on a home embroidery machine. They are attached with beads on their bodies and heads. As Sue worked on this piece, she let the flowers and colors guide her to the finish.

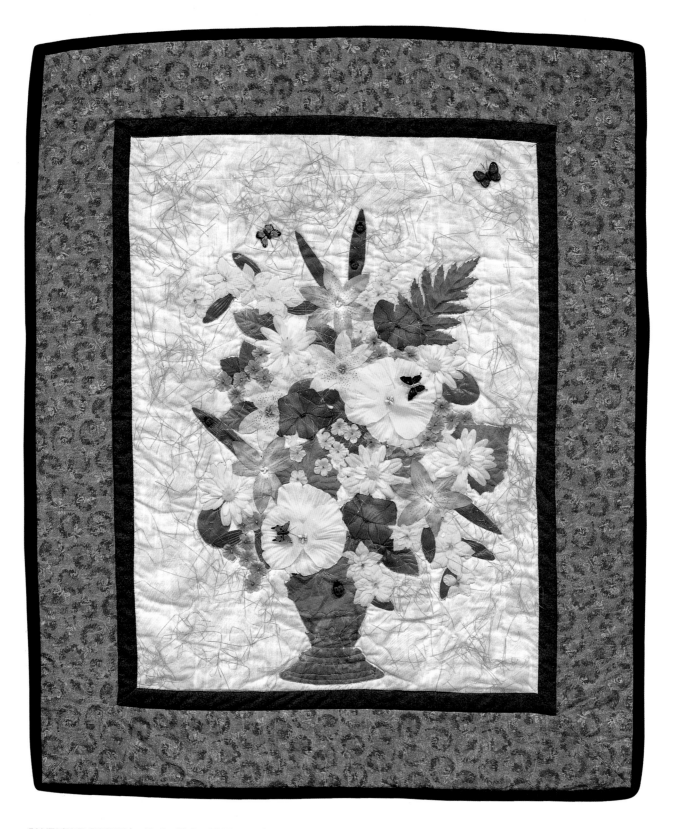

FANTASY FLOWERS by Kathy Klein, 2000, North Branch, New York, 32" x 38". Tintzl and silk flowers create this stunning bouquet. It is embellished with resin butterflies and ladybugs, as well as a butterfly pin.

Hand-Stitched Embellishments

There are a multitude of fancy threads and ribbons that you can use to complete your masterpiece. YLI Candlelight Metallic Yarns, metallic threads, and ribbons will all add beautiful sparkle to your flowers. Simple straight stitches and French knots are just two of the possible stitches you can use with these yarns and threads. Look through books on embroidery and silk ribbon embroidery for more inspiration. Also make sure that your needle is sharp enough to pierce the silk flowers, and avoid bulky yarns because it is very difficult to pull a large needle through the silk flowers.

3. Insert the needle right next to where the thread came out and pull to the back to form the knot.
4. Insert the needle back up into the fabric where you want to make the next knot and repeat the process until the desired area is filled.
5. Finish by knotting the thread or ribbon on the back.

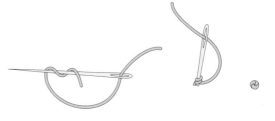

French Knots

French knots can be made with thread or silk ribbon. Silk ribbon gives a more realistic texture to the flower centers. The size of the flower will determine the size of the ribbon. I prefer the 2mm and 4mm silk ribbons. Smaller flowers will need fewer French knots and narrower ribbons, while larger flowers may need more knots and wider ribbon.

1. Knot the end of the thread or ribbon. Insert the needle from the back and pull to the top surface.
2. Wrap the thread or ribbon around the point of the needle twice.

Thread Ties

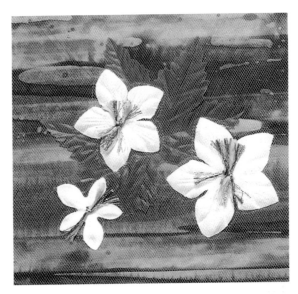

Ribbons, heavy threads, and decorative yarns can be used on the top surface of the flower to make a fuzzy center. Use a sharp needle with an eye just large enough to accommodate the thread, yarn, or ribbon.

1. From the top surface, take a stitch, leaving about a 3" tail. Cut the tail on the needle.
2. Tie the tails into a double knot. Pull tight to make a strong knot. Multistrand threads can be massaged with the fingertips to separate the fibers for a fuzzy effect.
3. Adding a dot of Fray Check or glue over the

knot will help it stay tied. Trim the ends as short or as long as desired.

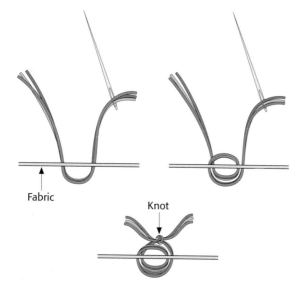

Fabric

Knot

Bead Embellishments

The variety of beads available is amazing—crystal, metallic, pearls, seed beads, bugle beads, colored, and molded. Each type will add a different look to a flower center. The simplest flower center is a single bead. You can also stitch clusters of beads to a flower center, using one type of bead or an interesting combination of beads.

Combining a bugle bead with a small bead at the end creates an interesting flower stamen. Adding several stamens to one flower will give you a dimensional flower center. When stitching combinations of beads as a stamen, come up through the bugle bead; then pull the thread through the top bead and back down through the bugle bead. Do not pull the thread back through the top bead.

Thread

Beads can also be combined with hand-stitched embellishments. For example, there is a lovely contrast of textures when you add lustrous beads to silk ribbon French knots. Seed beads add an element of interest to an area of French knots or thread ties.

Straight stitches combined with bugle beads create a realistic-looking center on the lily in "Botanical Print" on page 25.

Additional Embellishments
Buttons and Charms

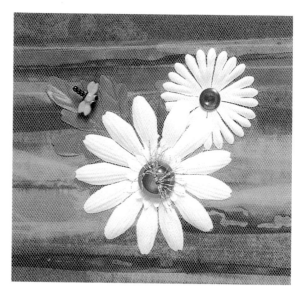

Single buttons or even groups of small buttons can be sewn to the center of a flower. Regular four-holed shirt buttons will give flowers a country flavor. A black velvet button would be perfect for the center of a black-eyed Susan. A crystal or rhinestone button offers an elegant flair to an ordinary flower. Look at your button collection with a new eye, searching for interesting flower centers. Susan

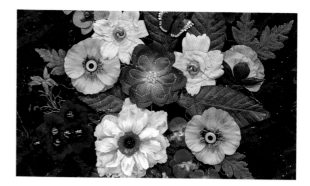

Detail of STILL LIFE #1 by Susan J. Sladek, 2000, Arlington, Virginia. This wall hanging features embellishments on top of the tulle. To add dimension, both the top layers of petals on the pink peony and the butterfly are attached over the tulle. All the flowers, except the one in the center, are embellished with buttons.

J. Sladek created some fun flower centers with buttons, shown in the photo below.

Leave knots on surface
if button will cover them.

When stitching a button, it is not necessary to bury the knot between the quilt layers. With the knot lying on top, stitch the button in place. Then take three small stitches in one place and tie a knot.

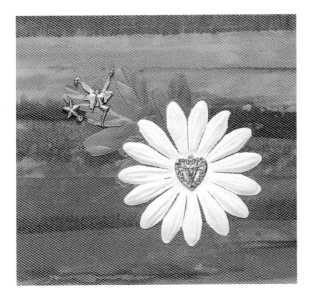

Like buttons, charms come in lots of different designs. Some charms may be the perfect center for a flower. Ladybugs, dragonflies, butterflies, and many other bugs are available as buttons or charms. Have fun and add a touch of nature to your quilt. To attach charms, stitch through the hole provided.

Ribbon Roses

Ribbon roses are another choice that will add interest and texture to your quilt. Premade ribbon roses make it easy to finish your flower centers. You can find these in many sewing and/or craft stores. Simply stitch or glue them to the flower center. Maria V. Weinstein incorporated ribbon roses, buttons, and a dragonfly charm in her bouquet.

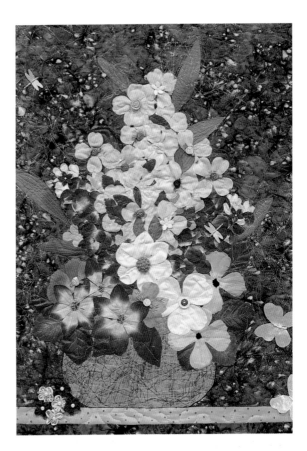

Detail of BUTTONS AND BUDS by Maria V. Weinstein, 2000, New City, New York, 34½" x 29½". Maria layered silk flowers on a batik background scattered with Tintzl. Then she covered everything with a gold metallic tulle. Embellishments of glass beads, embroidered French knots, more silk flowers, buttons, charms, and beaded butterflies cut from organza add interest to her quilt.

Glued Flower Centers

So far we've talked about centers that are attached or made with a needle and some kind of thread, ribbon, or yarn that is stitched to the surface. Glue is one way to really speed up the process of embellishing. It is best to use a glue especially designed for gluing beads to fabric. I find Gem-Tac to be particularly good for this purpose. Whatever glue you choose, however, be certain to test it on a spare flower and bead before using it on your quilt.

Squeeze a dab of glue on a scrap piece of paper. A toothpick is a handy tool for placing a small dot of glue on the spot where you want to place a bead. Use tweezers or a straight pin in the bead hole to pick up the bead and position it in the dot of glue. It will look best if you position the bead on its side

so that the hole is not visible on the top. Let the glue dry completely before moving the piece.

Side view

Top view

The Creative Crystal Company has some beautiful pearls, rhinestones, and metallic studs that come with a glue on the back that melts with heat.

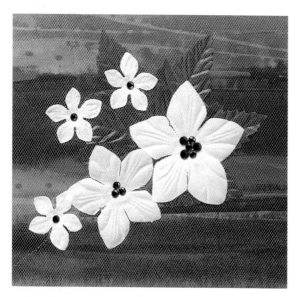

Creative Crystal also has a tool called the BeJeweler. With this tool, you just pick up the bead in the cupped tip of the BeJeweler, wait until the glue is bubbly, and press the rhinestone in place on the quilt.

The BeJeweler is a great help, but you can also melt the glue with an ordinary iron. Carefully position the embellishments such as rhinestones or studs in place. Cover them with a piece of paper. The paper will help protect the tulle from the heat of the iron. With the iron set on a medium temperature, place the iron over the paper and hold it in place. Do not move the iron around because this may move the embellishments you are gluing. Try to position the iron so that the flat surface, not the holes, is positioned over the embellishments. The time the iron needs to stay in place is determined by the size of the embellishment. Small rhinestones, for example, may take as little as 5 to 10 seconds, whereas larger rhinestones may take up to 20 to 30 seconds.

Remove the iron and the paper. Allow the embellishments to cool, and then check to see that all the embellishments are adhered to the surface. If any are loose, repeat the heating process with the paper. Add a few more seconds if several of the embellishments did not adhere to the surface.

Just for Fun

There are many other fun items that you can incorporate into your fantasy floral quilts. For example, motifs from novelty prints are a wonderful addition. Novelty prints can be found for just about any theme and include motifs such as teacups, cats, butterflies, birds, and birdhouses. When selecting a novelty print, make sure that the scale is appropriate to the design. Spray starch and iron the novelty prints before cutting them, which will help hold the fabric threads together while cutting and keep the edges from fraying. Handle the cut fabrics carefully. Pin the motifs in place before adding the tulle.

Motifs from various novelty prints can be cut out and added to fantasy floral quilts.

TIP: When you are finished with embellishing, take care when stitching the layers together. It is best to stitch around items like feathers, shells, and any other hard objects.

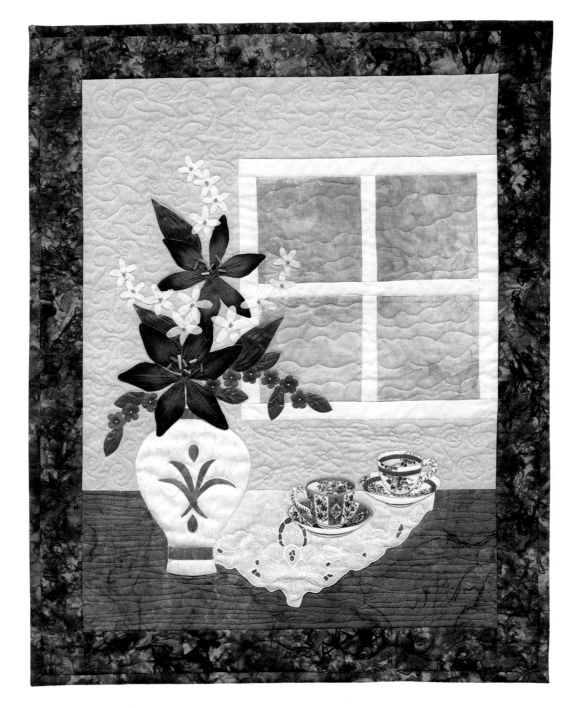

TEA FOR TWO by Bonnie Lyn McCaffery, 2000, Hawley, Pennsylvania, 26" x 32". A cut-fabric vase, bouquet, cutout teacups, and Battenberg lace are added to a pieced background.

BLUE FAIRY detail; see page 71 for full quilt. Sticking with the concept of "just for fun" embellishments, Sue C. Powell made a bird's nest by shaping leftover threads with her fingers. She then added seashells to look like eggs in the nest.

Finishing Options

Fabric Borders and Binding

I think of borders and binding as a framer thinks of a mat and frame. Your central design is your "painting" to be framed. And just as a framer would do, it's important to experiment with a variety of different mats and frames.

I usually wait until the central design is done before I even think about what fabrics to use for the borders. Once the central design is completed, choose a couple fabrics that you think might work for the borders and binding. Notice that I used the plural form of the word border. Framers will often use two mats—a narrow mat under a wider mat—and I use this same approach when adding borders to the central design.

Arrange the "framing" fabrics in order with the binding fabric first, the outer-border fabric second, and the inner-border fabric last. Place a corner of the central design on top of the arranged fabrics. Layer the fabrics and design so that the amount of fabric exposed is equivalent to the desired finished size of each of the fabrics in their specified position. For example, ½" for the inner border, 3" for the outer border, and ½" for the binding.

Take a look at the combination of fabrics as they relate to the central design. Use a reducing lens or camera to see a distant view of the piece. Does the inner border blend too much with the design? Change it to a brighter, lighter, darker, or contrasting color. Does the combination need spark? Try adding a bright color for the binding. Do the fabrics appear to be segmented and not coordinated very well? Try selecting a border fabric that has many of the colors used in both the flowers and the background, which will help tie the project together.

If you find a group of fabrics that you think may work, test the remaining three corners of the central design on the arranged fabrics to make certain that they create a pleasing combination.

Floral Borders

If you are having a difficult time finding just the right color for the outer border, you can actually create a fabric with some of the same silk flowers you used in your central design. The border is another area where you can add silk flowers to enhance the beauty of your design. One easy way to do this is to sew the borders to the background fabric before positioning flowers and leaves. Once the

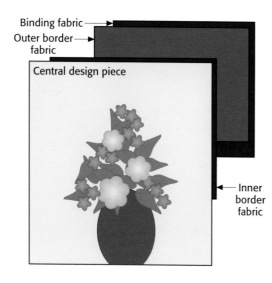

Keep flowers ⅝" from outer edge.

borders are attached, add the flowers to the central design and the borders at the same time. Keep all flowers and leaves at least ⅝" from the outer edges to allow room for stitching the binding.

When you've positioned all the flowers and leaves, layer the tulle on top of the entire piece and stitch the layers together. The "Pieced Blocks and Flowers" project quilt on page 62 and Lillian Angus's "Glitter Glow," below, were made this way.

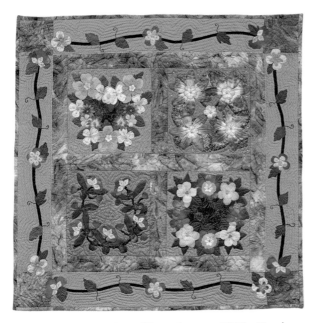

GLITTER GLOW by Lillian Angus, 2000, Hawley, Pennsylvania, 40" x 40". A four-block sampler with silk flower borders.

Another option for floral borders is to cut each border piece to size, including seam allowances. Then treat each piece as an area on which to create a fantasy floral design, following the same basic steps as you did for making the central design. This option allows you to use a different color of tulle on the central design and the borders. When all the pieces are complete, sew them together in the traditional manner. Layer the quilt with batting and backing; then baste and quilt. "Valentine Floral Heart" on page 74 was made this way.

When creating each of the border pieces, remember to keep all flowers and leaves ⅝" from the outer edges where pieces will be joined to each other and where the binding will be stitched.

Another possibility is to add flowers in the border that overlap the central design, as shown in "Turkish Fantasy," below. Tülin created the central design, and I added the borders. I positioned the flowers to overlap the central design and covered the entire piece—including borders—with tulle. The stitching was done around the flowers and along the edges of the central design. The tulle was trimmed away from the central design. The edges of the remaining tulle were then stitched with clear thread and a zigzag stitch.

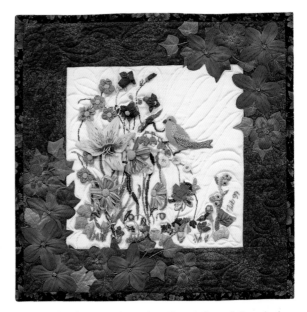

TURKISH FANTASY by Tülin Alacaatli and Bonnie Lyn McCaffery, 2000, Ankara, Turkey, and Hawley, Pennsylvania, 18" x 18". This quilt was made as a combined effort of two artists through a Turkish and American block exchange.

Nine-Block Sampler

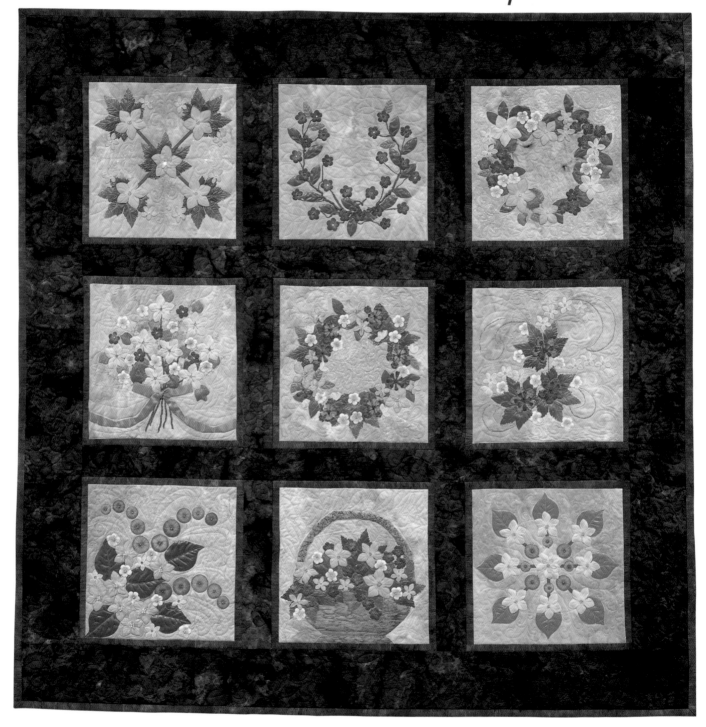

Bonnie Lyn McCaffery, 2000, Hawley, Pennsylvania, 54½" x 54½".
From left to right and top to bottom: Sampler Blocks 3, 6, 2, 5, 1, 8, 9, 7, and 4.

BALTIMORE ALBUM QUILTS HAVE REACHED AN ALL-TIME HIGH IN THE CATEGORY OF FAVORITE KINDS OF QUILTS. In a typical Baltimore Album quilt, you'll find a variety of block styles. These styles range from symmetrical to baskets to free-form designs. A sampler quilt is a great way to create your own album-style quilt. And with the techniques presented in this book, it will not take you years to make one. Imagine how much faster it is to capture silk flowers under tulle rather than appliqué every petal and leaf.

Making the sampler blocks will also give you the opportunity to experiment with different styles, materials, techniques, and embellishments. You can make one block or the complete "Nine-Block Sampler." Once you understand the elements, backgrounds, and techniques, you can mix and match to create your own blocks. I have included a creative hint with each block to encourage you to experiment and play with making your own blocks.

NOTE: *The following lists include all materials required to create "Nine-Block Sampler." The general and individual block directions list only the materials required to create one block.*

Fabric: 42" wide

- 1¼ yds. light print for block backgrounds
- 9" x 9" square of fabric for heart in Sampler Block 2
- ¼ yd. brown basketlike print for basket in Sampler Block 7
- ½ yd. purple print for block border
- 1¾ yds. dark blue-and-green print for sashing and outer border
- 3¼ yds. for backing
- ½ yd. for binding

Additional Materials

- 4 yds. Pellon Stitch-n-Tear
- 1½ yds. tulle
- Optional: 9"-diameter circle of white tulle for Sampler Block 1
- Silk flowers: a selection of small, medium, and large flowers ranging from 1" to 2¼". I used Teters Floral Products, Inc., Peach and Golden Yellow Large Delphiniums, Purple Lilacs, Green Island Bell, Purple and Kiwi Double Baby's Breath Spray.
- 1 bag Red Iridescent Tintzl
- 9" x 9" square of paper
- 1 spool Silver YLI Kaleidoscope Thread
- 1 pkg. Light Brown Clover Quick Bias Tape
- 1 spool green thread
- 1 pkg. green 4mm silk ribbon

- 1 yd. ½"-wide ribbon
- 1 pkg. brown 7mm silk ribbon
- Air-erasable marking pen
- 1 spool Midnight YLI Candlelight Yarn
- Size 20 chenille needle
- 1 spool variegated metallic thread
- 1 spool each of smoke and clear transparent thread
- Embellishments (see "Adding Embellishments" on pages 41–47)
- 56" x 56" piece of batting

Cutting for the Nine-Block Sampler

All measurements include ¼"-wide seam allowances.

From the purple print, cut:
- 18 strips, each 1" x 12½", for block side borders
- 18 strips, each 1" x 13½", for block top and bottom borders

From the dark blue-and-green print, cut along the lengthwise grain:
- 6 strips, each 3" x 13½", for vertical sashing
- 2 strips, each 3" x 44½", for horizontal sashing
- 2 strips, each 5½" x 44½", for outer side borders
- 2 strips, each 5½" x 54½", for outer top and bottom borders

From the fabric for binding, cut:
- 6 strips, each 2" x 42"

Assembling the Nine-Block Sampler

Follow the directions on pages 52–59 to make the individual blocks; then follow the steps below to complete the quilt.

1. Stitch a 1" x 12½" purple border strip to the left and right side of each block. Stitch a 1" x 13½" purple border strip to the top and bottom edges of each block. Press seams toward the purple border.

CAUTION: *Remember that the block is covered with tulle; set the iron at a medium temperature.*

2. Arrange the blocks in 3 rows of 3 blocks each, with dark blue-and-green 3" x 13½" vertical sashing strips between the blocks in each row. Stitch the blocks and sashing strips together in horizontal rows. Press seams toward the sashing.

3. Stitch the rows of blocks together, adding the dark blue-and-green 3" x 44½" horizontal sashing strips between the rows. Press seams toward the sashing.

4. Stitch a dark blue-and-green 5½" x 44½" outer-border strip to the left and right sides of the quilt top. Press seams toward the outer border. Stitch the dark blue-and-green 5½" x 54½" outer-border strips to the top and bottom edges. Press seams toward the outer border.

5. Layer, baste, quilt, and bind the quilt.

6. Embellish the centers of the flowers as desired. Refer to "Adding Embellishments" on pages 41–47.

General Directions for Sampler Blocks

The finished size of all blocks is 12" x 12". For specific design guidelines, refer to the individual block directions following this section.

1. Cut the following for each block:
- 1 square, 13" x 13", of light print for background
- 1 square, 13" x 13", of tear-away stabilizer such as Pellon Stitch-n-Tear
- 1 square, 13" x 13", of tulle
 Additional materials may be required and are listed separately in the individual block directions.

2. Lay the background square on top of the tear-away stabilizer.

3. Arrange all flowers and leaves as instructed in the individual block directions, keeping the items at least 1" from the edge of the background square.

4. When all elements are in place, carefully lay the tulle over the center. Pin and stitch the layers together with clear transparent thread.

5. Remove the tear-away stabilizer. Trim the edges of the block so that it measures 12½" x 12½". The block is now ready to frame, add borders, or use in a sampler.

Directions for Individual Sampler Blocks

Sampler Block 1: Circular Wreath

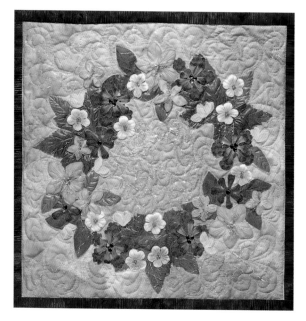

- Optional: 9"-diameter circle of white tulle
- Silk flowers: a selection of small and medium flowers ranging from 1" to 2". I used Teters

Floral Products, Inc., Peach and Golden Yellow Large Delphiniums, Purple Lilacs, and Kiwi Double Baby's Breath Spray.

- 1 bag Red Iridescent Tintzl

1. Fold the light-print background square in half vertically and horizontally; finger-press the folds. Do the same with a 9" circle of white tulle. Center the circle of tulle on the background square.

NOTE: *If you choose not to use a 9" white tulle circle, draw a 9" circle on the background square with an air-erasable marking pen.*

2. Arrange the flowers in a circular wreath by using the edge of the tulle or circle as a guide. Be sure to cover the edge of the tulle circle.
3. Add Red Iridescent Tintzl to the background if desired.

CREATIVE HINT: You can draw any shape on the background as a guideline for flower placement.

Sampler Block 2: Heart Wreath

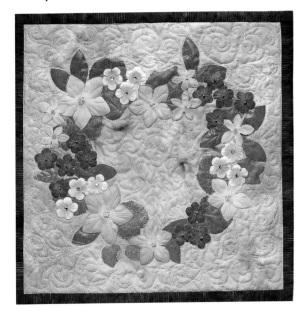

- 9" x 9" square of paper for heart template
- 9" x 9" square of fabric for heart
- 1 spool Silver YLI Kaleidoscope Thread
- Silk flowers: a selection of small and medium flowers ranging from 1" to 2¼". I used Teters Floral Products, Inc., Peach and Golden Yellow Large Delphiniums and Kiwi Double Baby's Breath Spray.

1. Fold the piece of paper in half vertically, and cut a heart measuring approximately 7" wide and 7" tall. You can cut the heart freehand, or draw half a heart before cutting. Check the template for size on the background square. Recut and adjust as necessary.

Fold

2. Use the heart template to cut a heart from the 9" x 9" square of fabric.

3. Fold the background square and the fabric heart in half vertically to find their centers. Center the fabric heart on the background square. Arrange the flowers by using the edge of the fabric heart as a guide, making sure to cover the edges. The distance from the flowers to the left and right edges of the square should be equal.

4. Drizzle the Silver YLI Kaleidoscope Thread on the background.

CREATIVE HINT: You can experiment with different printed fabrics for the heart.

Sampler Block 3: "X" Marks the Spot

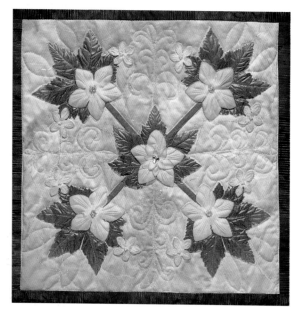

- 20" length of Light Brown Clover Quick Bias Tape
- Silk flowers: a selection of small and medium flowers ranging from 1" to 2¼". The important thing to remember when selecting the flowers for this block is that you will need 5 medium flowers that are the same size and 9 small flowers that are the same size, as well as 5 large leaves. I used Teters Floral Products, Inc., Peach Large Delphiniums.
- 1 bag Red Iridescent Tintzl

1. Fold the background square in half diagonally in both directions. Finger-press the folds.

2. Cut two 10" lengths of bias tape. Fold the bias tape in half to find the center point; finger-press. Remove the release liner and position the bias tape along the crease line. Align the center point on the bias tape with the center of the background square. Do the same with the second piece of bias tape. Press the bias tape in place.

3. Place a large leaf and medium flower at the end of each piece of bias tape. Use a ruler if necessary to make sure that the leaves are the same distance from the edges of the square. Place a large leaf and medium flower at the center of the **X**. Place a small flower on each side of the corner leaves. Again, check for symmetry.

4. Add Red Iridescent Tintzl to the background if desired.

CREATIVE HINT: Create many different structures on which to place flowers with Clover Quick Bias Tape. Some of the structures may include a circle, a square, stems in a bouquet, stems radiating from a corner, and curvy shapes.

Sampler Block 4: Symmetrical Star

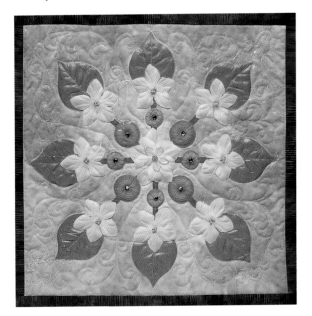

- 45" length of Light Brown Clover Quick Bias Tape
- Silk flowers: a selection of small and medium flowers ranging from 1" to 2¼". You will need 8 flowers of the same size, 8 leaves of the same size, and 8 circular leaves and flowers for the center. I used Teters Floral Products, Inc., Golden Yellow and Peach Large Delphiniums, Green Island Bell, and leaves from Purple Lilacs.
- 1 bag Red Iridescent Tintzl

1. Fold the background square in half diagonally in both directions. Then fold the square in half horizontally and vertically; finger-press the folds.

2. From the 45" length of bias tape, cut two 12" lengths and two 10" lengths. Fold the lengths of bias tape in half to find the center points; finger-press. Remove the release liner. With the center points of the bias tape and the square aligned, position the 12" lengths on the diagonal creases to form an X. Then position the 10" lengths on the horizontal and vertical creases to form a cross. Press the lengths of bias tape in place.

3. Place a large leaf at the end of each piece of bias tape; each leaf should be the same distance from the center point. Add a flower at the base of each leaf. Add alternating small and medium round leaves toward the center. Add a medium flower, covered with a second medium flower and a small flower, at the center of the design. Be sure to check for symmetry.

4. Add Red Iridescent Tintzl to the background if desired.

CREATIVE HINT: You can use just the crease lines as a guide for creating your own symmetrical design. Be sure that each matching flower or leaf is the same distance from the center.

Sampler Block 5: Nosegay Bouquet

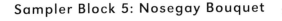

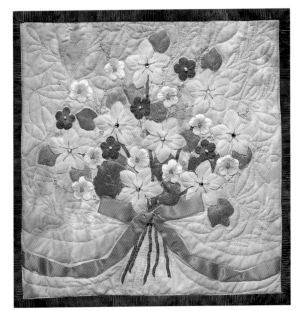

- 1 spool green thread
- 1 pkg. green 4mm silk ribbon
- Silk flowers: a selection of small and medium flowers ranging from 1" to 2". I used Teters Floral Products, Inc., Golden Yellow Large Delphiniums, Purple and Kiwi Double Baby's Breath Spray.
- 1 yd. ½"-wide ribbon

1. Choose a decorative stitch on the sewing machine and stitch some greenery on the background where the bouquet will be located. Refer to "Stitching Greenery" on pages 20–21.

2. Fold the background square in half vertically; finger-press the fold. Cut six 10" lengths of green 4mm silk ribbon. If necessary, iron the ribbons. Lay the ribbons on the background square so that they intersect on the center crease about 4" from the bottom edge. Cut the bottom ends of the ribbons at an angle so that they are 1" to 2" from the bottom edge of the square.

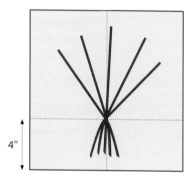

3. Position small and medium-sized flowers, and some small leaves over the stems to create an airy bouquet.

4. Tie 1 yard of ½"-wide ribbon into a bow. Place the bow over the intersection of the ribbon stems. Fold the tails of the bow to change the direction of the ribbon so the tails go off the side edges of the square. Use small-headed pins to temporarily hold the ribbon in position until it is sewn in place.

CREATIVE HINT: Background stitched greenery can also be used in wreaths, basket bouquets, and several other sampler block designs.

Sampler Block 6: Horseshoe Wreath

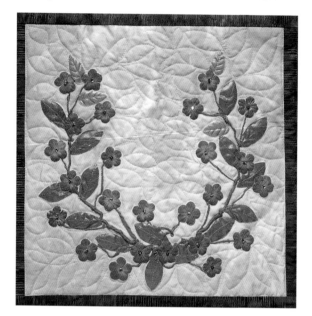

- Air-erasable marking pen
- 1 pkg. brown 7mm silk ribbon
- 1 spool smoke transparent thread or thread to match the branches
- Silk flowers: a selection of small flowers. I used Teters Floral Products, Inc., Purple Double Baby's Breath Spray.

1. Fold the background square in half vertically; finger-press the fold. With an air-erasable marking pen, draw an 8" or 9" circle centered on the square. Draw a horizontal line about 3" from the top edge of the square to mark the position of the top of the wreath.

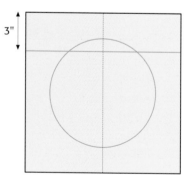

2. Referring to "Twisted Branches" on page 27, use fourteen to sixteen 12" lengths of brown 7mm silk ribbon to create the twisted branch wreath; use the drawn reference lines as a

guide. Start at the top and work down the left and right sides to the base of the wreath. Pin the ends and the connections as necessary with large-headed pins. As the left and right ribbon groups meet at the base of the wreath, twist the separate ends and pin them in place. With smoke transparent thread or thread to match the branches, bartack the branches at each pin point.

3. Position small flowers at the ends of the branches. Fill in the wreath to create an airy symmetrical design, tucking a few leaves under the branches.

CREATIVE HINT: Twisted branches can be made in a variety of shapes, including wreaths and bouquets.

Sampler Block 7: Basket of Flowers

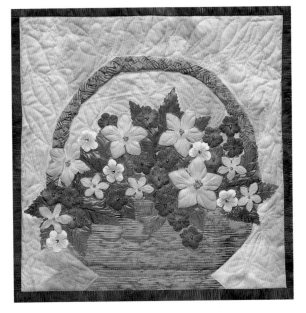

- ¼ yd. brown basketlike print
- 8½" x 11" piece of paper for basket template
- Silk flowers: a selection of small and medium flowers ranging from 1" to 2". I used Teters Floral Products, Inc., Peach Large Delphiniums, Purple and Kiwi Double Baby's Breath Spray.

1. Cut 3 strips, each 1" wide, from the crosswise grain of the basket fabric and set aside.

2. Fold a piece of paper in half vertically; finger-press the folds. Cut a symmetrical basket shape (without the handle). Do this freehand or draw a shape first.

Open the paper to see how the basket template looks. It should be approximately 9" x 4". Test it on the background; reshape as necessary. Use the template to cut the basket shape from the remaining basket fabric. No seam allowances are necessary because the cut basket will be under the tulle. Treat the cut edges carefully; they will fray if mishandled.

3. Fold the background square and the basket in half to find the center of the bottom edges; finger-press the folds. Place the basket ⅜" from the bottom edge of the background square, centering it horizontally. Braid the three 1" widths of basket fabric from step 1. Place the braid at the ends of the basket and form the braid into an arch. Note that you will not use the full length of braid. Pin the braid at the basket edges. Straight stitch across the ends where the braid meets the basket base. Trim the excess braid.

4. Place flowers and leaves in the basket. Be sure to use a leaf or flower to cover the ends of the braid. Allow flowers and leaves to tumble over the edges of the basket.

NOTE: *When squaring up the block, use the basket bottom as a starting reference. The basket bottom should end up ¼" from the bottom edge of the background square. Use this cut edge as a reference to cut the square. Be sure that the basket is centered on the background.*

CREATIVE HINT: Have fun experimenting and creating your own basket or vase design to fill.

Sampler Block 8: Fleur-de-Lis

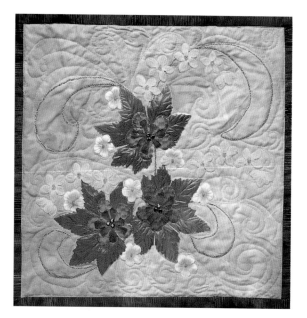

- Air-erasable marking pen
- 1 spool Midnight YLI Candlelight Yarn
- 1 spool smoke transparent thread
- Size 20 chenille needle
- Silk flowers: a selection of small and medium flowers ranging from 1" to 1¾". I used Teters Floral Products, Inc., Golden Yellow Large Delphiniums, Purple Lilacs, and Kiwi Double Baby's Breath Spray.

1. Fold the background square in half horizontally and vertically to divide the square into quarters; finger-press the folds. Referring to the center lines for placement, place each quarter of the background square on top of the corresponding pattern (pages 60–61). Trace the patterns on each quarter of the square with an air-erasable marking pen.

2. Couch the Midnight YLI Candlelight Yarn along the pattern lines with a narrow zigzag stitch and smoke transparent thread. Leave 6" to 8" thread tails of the yarn at the beginning and end of a line. When done, thread the tails on the chenille needle and pull them to the back of the square. Knot the ends and trim the excess thread.

3. Place 3 large leaves with medium-sized flowers near the center of the design. Add smaller flowers randomly around the leaves and along the curved lines. Be sure you do not cover the stitched curved lines.

CREATIVE HINT: Have fun creating your own thread design in the background. Experiment with fancy script letters.

Sampler Block 9: Radiating Corner

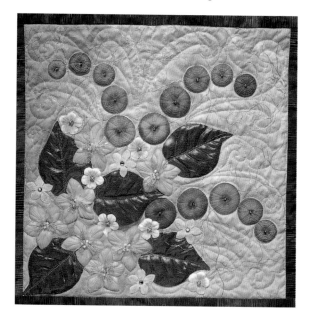

- 1 spool variegated metallic thread
- Silk flowers: a selection of small and medium flowers ranging from 1" to 2". I used Teters Floral Products, Inc., Peach and Golden Yellow Large Delphiniums, Green Island Bell, leaves from Purple Lilacs, and Kiwi Double Baby's Breath Spray.

1. Drizzle metallic thread on the background square.

2. Place flowers so they radiate out from one

corner of the square. The flowers and leaves should be dense near the corner and have more space between them as they move away from the corner. Create curved lines of Green Island Bell circles extending out from the corner. Place the leaves in lines of graduating sizes, from larger to smaller, and extending from the corner.

CREATIVE HINT: Play with the flowers as in the "Silk-Flower Color Play" section on page 36 to create a block.

Variations

Whether you choose to do one block or all nine, there are many ways to set blocks. It can be as simple as adding borders around just one block. You can arrange three, four, or five blocks in a horizontal or vertical row, or in a traditional four-block or nine-block setting. You can set the blocks with or without sashing between them.

FLOWERS! FLOWERS! FLOWERS! by Helen Umstead, 2000, Hawley, Pennsylvania, 40" x 40". This is an example of a lovely four-block sampler.

SIMPLY COUNTRY by Monica Cespino-Dowd, 2000, Staten Island, New York, 20" x 53". This three-block sampler on gingham checked backgrounds is bordered with denim. The blocks are covered with large-holed black netting. A resin butterfly, ladybug, and dragonfly are captured under the mesh. The flower centers are embellished with French knots.

SUMMER WREATH by Patti Shreiner, 2001, Shohola, Pennsylvania, 20½" x 20½". Set against a blue summer sky, this wreath has a wealth of flowers that Patti wished she'd collected from her own garden. The quilting designs were patterned after the trellis and edging in one of Patti's garden beds. The beads in the flower centers include pearls, bugles, and seed beads. The centers are embroidered with YLI 1000 Denier Silk Thread, gold metallic thread, and gathered rachel thread.

Sampler Block 8
Fleur-de-Lis

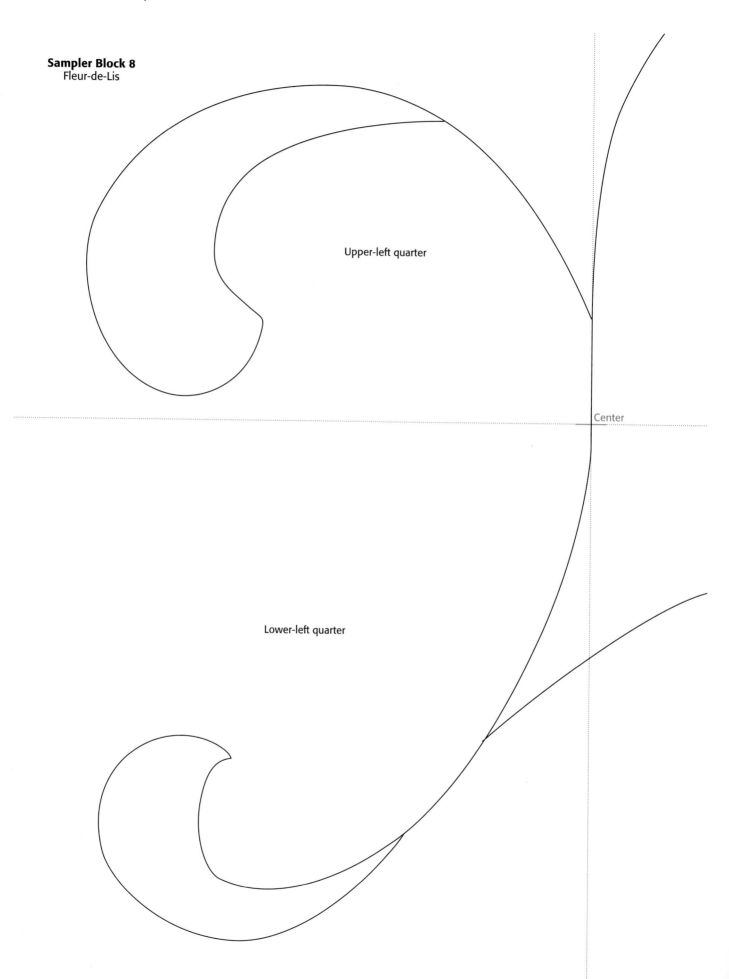

Upper-left quarter

Center

Lower-left quarter

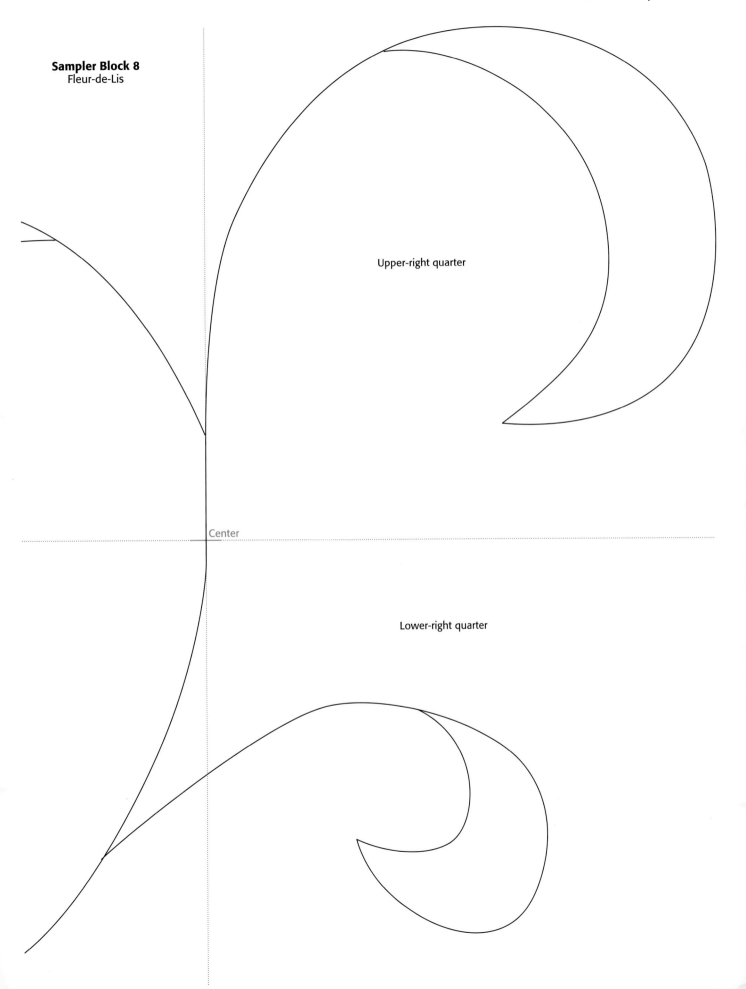

Sampler Block 8
Fleur-de-Lis

Upper-right quarter

Center

Lower-right quarter

Pieced Blocks and Flowers

Bonnie Lyn McCaffery, 2000, Hawley, Pennsylvania, 42" x 42". A pieced foundation with yellow flowers
is topped with a layer of purple tulle and embellished with iron-on rhinestones.

THIS PROJECT WILL GIVE YOU EXPERIENCE WORK-ING ON A PIECED BACKGROUND.

Fabric: 42" wide

- ¼ yd. light blue print for blocks
- ½ yd. multicolored print for blocks and outer border
- ½ yd. dark blue print for blocks
- 1½ yds. dark green print for blocks and outer border
- ⅝ yd. purple print for blocks
- ½ yd. magenta print for blocks and inner border
- 2⅝ yds. for backing
- ½ yd. for binding

Additional Materials

- 2½ yds. Pellon Stitch-n-Tear
- Silk flowers: I used 4 stems of Yellow Large Delphiniums, 4 stems of Golden Yellow Small Lotus, and leaves from a 6' Wisteria Garland—all from Teters Floral Products, Inc. However, you can use whatever flowers you like. The design will require:

 Twenty 3" yellow flowers
 Twenty-four 2½" yellow flowers
 Eight 2" yellow flowers
 Forty-five 1" yellow flowers
 Eighty-eight 1" x 3" pointed leaves

- Beacon Fabri-Tac permanent adhesive
- 1 spool smoke transparent thread
- 2 yds. of purple tulle
- 46" x 46" piece of batting
- Embellishments (see "Adding Embellish-ments" on pages 41–47)

Cutting

Use piecing templates made with patterns on pages 66–67. All measurements include ¼"-wide seam allowances.

From the light blue print, cut:

- 16 and 16 reversed of Template 1 for blocks

From the multicolored print, cut:

- 16 and 16 reversed of Template 2 for blocks
- 4 squares, each 6" x 6", for outer border

From the dark blue print, cut:

- 16 and 16 reversed of Template 3 for blocks

From the dark green print, cut:

- 16 and 16 reversed of Template 4 for blocks
- 4 strips, each 6" x 33½", for outer border

From the purple print, cut:

- 16 and 16 reversed of Template 5 for blocks

From the magenta print, cut:

- 16 of Template 6 for blocks
- 2 strips, each 1" x 32½", for inner side borders
- 2 strips, each 1" x 33½", for inner top and bottom borders

From the fabric for binding, cut:

- 5 strips, each 2" x 42"

From the tear-away stabilizer such as Pellon Stitch-n-Tear, cut:

- 2 rectangles, each 22" x 44"

From the tulle, cut:

- 1 square, 44" x 44"

Piecing the Background Fabric

1. Stack all like block pieces right side up and arrange them so that they look like the block design.

2. Stitch pieces 1, 2, 3, 4, and 5 together as shown to make section A. Press the seams in the direction of the arrows. Repeat to make section B with pieces 1r, 2r, 3r, 4r, and 5r.

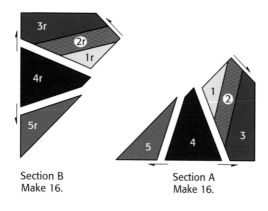

Section B
Make 16.

Section A
Make 16.

3. Stitch section A and section B together, then add a piece 6 to the corner. Make 16 blocks.

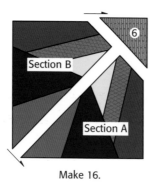

Make 16.

4. Arrange the blocks in 4 rows of 4 blocks each, rotating the blocks as necessary to form the design.

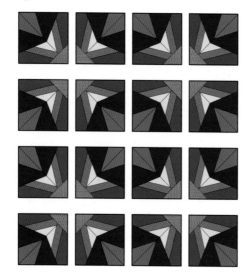

5. Stitch the blocks into horizontal rows. Press the seams in opposite directions from row to row. Join the rows.

6. Stitch a 1" x 32½" inner-border strip to the left and right sides of the pieced background fabric. Sew a 1" x 33½" inner-border strip to the top and bottom of the pieced background fabric. Press the seams toward the inner border.

7. Stitch a 6" x 33½" outer-border strip to the left and right sides of the pieced background fabric. Add a 6" multicolor square to each end of the remaining 6" x 33½" outer-border strips. Stitch these to the top and bottom edges.

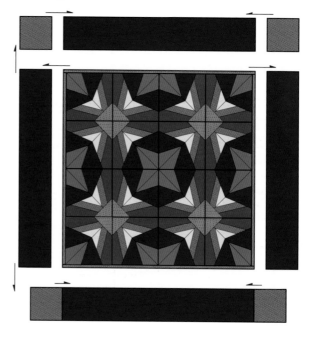

Adding the Flowers

1. Press the tear-away stabilizer and lay the pieces on a flat surface, overlapping the long edges about ½" (see page 13). Pin the stabilizer at the edges. Place the pieced background fabric on top of the stabilizer.

2. Position flowers and leaves on each block as shown. Use a tiny dot of Fabri-Tac to hold them in place.

3. Working from the center toward the corners, add the remaining flowers to each border as shown. Position the flowers symmetrically on each of the borders. The flowers should not extend any further than 4" from the edge of the inner border, which will allow room for trimming the edges and stitching the binding. Add 5 additional small flowers at the block intersections as shown.

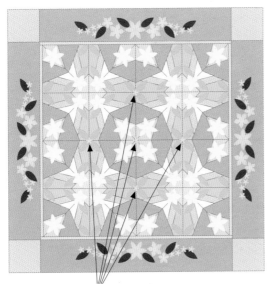

Flowers at block intersections

4. Inspect the surface for any stray particles. Lay the tulle on top of the entire design. Remove the pins at the edges of the stabilizer. Carefully pin the layers; then stitch the layers together with transparent thread.

Finishing

1. Remove the tear-away stabilizer. Trim the edges of the quilt to measure 42" x 42".

2. Layer, baste, quilt, and bind the quilt.
3. Embellish the centers of the flowers as desired.

CAUTION: *Remember that the central design is covered with tulle and the iron should be set at a medium temperature.*

Adding Silk Flowers to Pieced Projects

Once you begin to play with the flowers, you will find that pieced fabric is a wonderful background for them. The curves of the flowers contrast wonderfully with geometrically pieced designs. Flowers can be captured on individual blocks that are then pieced together to form the central design, or they can be captured on an already pieced background. I prefer the latter process if the resulting piece is not too large to work with on the sewing machine. For symmetrical designs, it is important that the flowers be the same size and placed on the same position in each block.

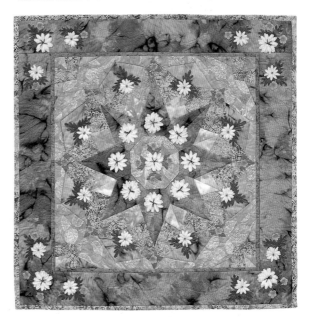

MEADOWSWEET by Patti Shreiner and Bonnie Lyn McCaffery, 2000, Shohola, Pennsylvania, and Hawley, Pennsylvania, 35" x 35". Quilted by Lori Nixon. The flowers in "Meadowsweet" were positioned in identical positions on this kaleidoscope design. This quilt was created as a joint effort by the three artists. Bonnie created a foundation-pieced kaleidoscope topped with silk flowers. Lori machine quilted it and Patti embellished it.

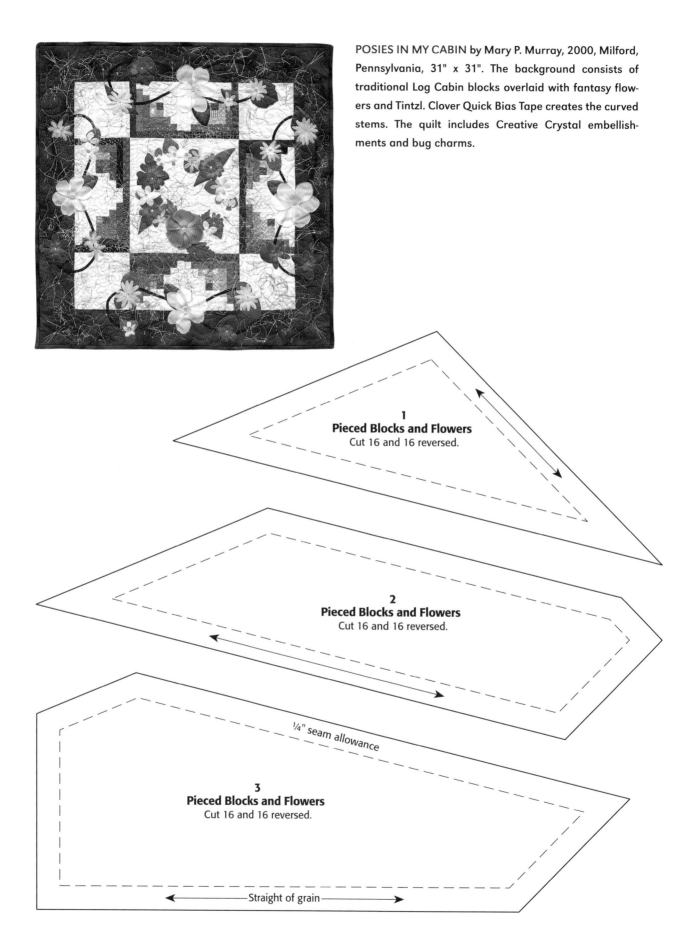

POSIES IN MY CABIN by Mary P. Murray, 2000, Milford, Pennsylvania, 31" x 31". The background consists of traditional Log Cabin blocks overlaid with fantasy flowers and Tintzl. Clover Quick Bias Tape creates the curved stems. The quilt includes Creative Crystal embellishments and bug charms.

1
Pieced Blocks and Flowers
Cut 16 and 16 reversed.

2
Pieced Blocks and Flowers
Cut 16 and 16 reversed.

¼" seam allowance

3
Pieced Blocks and Flowers
Cut 16 and 16 reversed.

← Straight of grain →

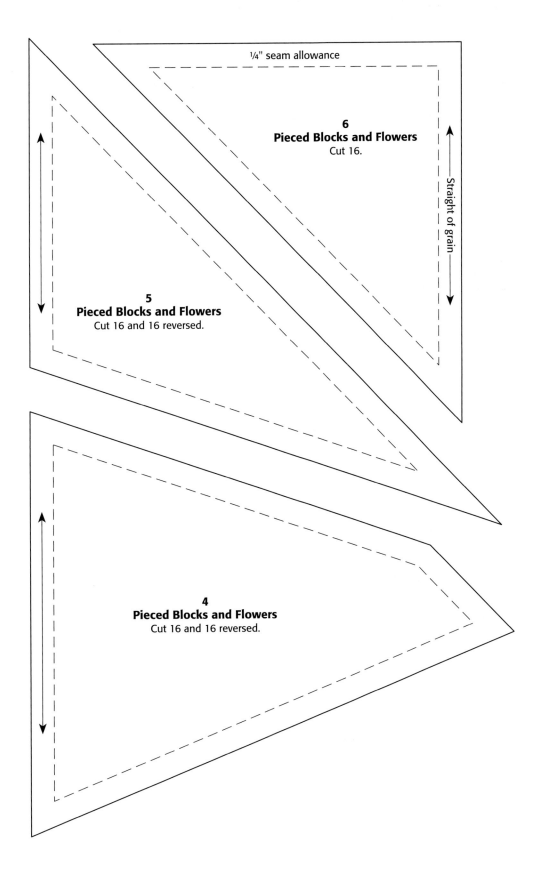

¼" seam allowance

6
Pieced Blocks and Flowers
Cut 16.

Straight of grain

5
Pieced Blocks and Flowers
Cut 16 and 16 reversed.

4
Pieced Blocks and Flowers
Cut 16 and 16 reversed.

Fantasy Tree Fairy

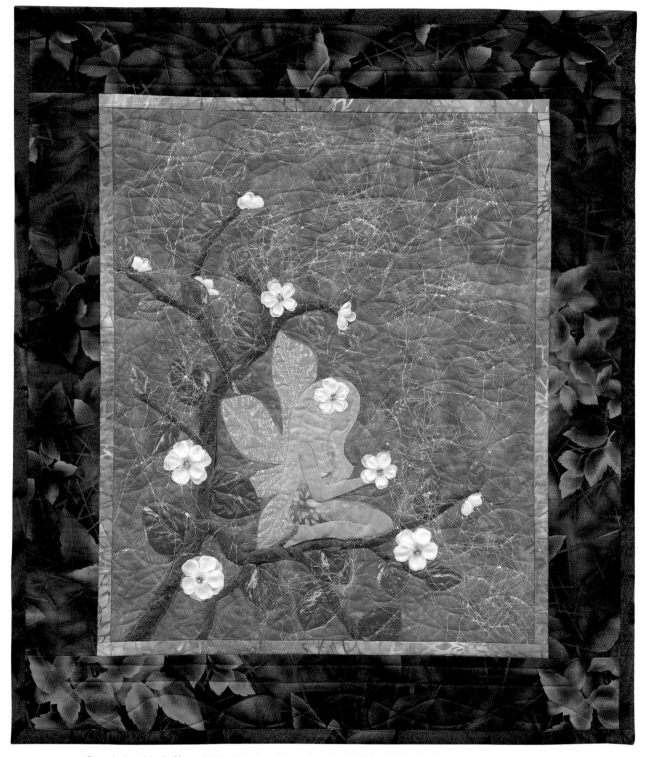

Bonnie Lyn McCaffery, 2000, Hawley, Pennsylvania, 23½" x 27½". The branches are created using the twisted branch technique. The project includes Blue Iridescent Tintzl in the background.

THIS PROJECT WILL GIVE YOU EXPERIENCE CREAT-
ING TWISTED BRANCHES.

Fabric: 42" wide

- 10" square of skin-tone fabric
- 6" square of hair-colored fabric
- 8" square of light blue sheer fabric for wings
- 6" square of multicolored print for dress
- ⅝ yd. blue print for background
- ⅜ yd. brown print for twisted branches (see "Branch Materials" on page 27)
- ¼ yd. pink print for inner border
- ¾ yd. dark blue print for outer border and binding
- ¾ yd. for backing

Additional Materials

- 8½" x 11" piece of freezer paper
- 8½" x 11" sheet of tracing paper
- 1 spool each of smoke and clear transparent thread
- Silk flowers and leaves ranging in size from ½" to 1½" (The number of flowers and leaves used is up to you.)
- 1 pkg. Blue Iridescent Tintzl
- ⅝ yd. piece of Pellon Stitch-n-Tear
- ⅝ yd. blue tulle
- 26" x 30" piece of batting
- Embellishments (see "Adding Embellishments" on pages 41–47)

Cutting

All measurements include ¼"-wide seam allowances.

From the blue print, cut:
- 1 rectangle, 18" x 21", for background

From the brown print, cut:
- 8 or 9 strips, each 1" x 42", for twisted branches

From the pink print, cut:
- 2 strips, each 1" x 17½", for inner side borders
- 2 strips, each 1" x 20½", for inner top and bottom borders

From the dark blue print, cut:
- 2 strips, each 3½" x 21½", for outer side borders
- 2 strips, each 3½" x 23½", for outer top and bottom borders
- 4 strips, each 2" x 42", for binding

From the tear-away stabilizer such as Pellon Stitch-n-Tear, cut:
- 1 rectangle, 18" x 21"

From the blue tulle, cut:
- 1 rectangle, 18" x 21"

Creating the Central Design

1. Trace the patterns on page 72 onto the dull side of the freezer paper. Cut the pattern pieces apart. You do not need to cut them out accurately yet.
2. Iron the shiny side of the pattern pieces to the back of the corresponding fabrics with a medium-temperature iron. Note that the pattern pieces are reversed. Cut each piece out on the drawn line with sharp scissors.
3. Trace the complete fairy pattern on page 73 onto a piece of tracing paper. Cut the fairy out as one unit. This pattern will be used as a reference while creating the twisted branches.
4. Lay the background fabric on the stabilizer. Place the tracing paper fairy in the desired position on the background fabric.
5. Referring to "Twisted Branches" on page 27, use the 1"-wide brown strips to create branches on the background fabric. Do not place any branches where the fairy will be located. Be sure to place one branch for the fairy to kneel on. Bartack the branches with the smoke transparent thread.

6. Carefully remove the freezer paper from the back of the fairy pieces. Assemble the fairy with the tracing-paper fairy pattern as a reference. Position the wings first and then the hair. Slide the face into the cut in the hair piece.

Add the dress and finally the arm. Once all the pieces are in place, carefully remove the tracing paper fairy pattern. Be sure that the fairy appears to be kneeling on the branch.

7. Add flowers and leaves to the branches. Fold some flowers to look like buds. Put a flower in the fairy's hand and in her hair. Other options for the fairy's hair and hand are shown below.

8. When all flowers, leaves, and fabric pieces are in place, spread some Blue Iridescent Tintzl on the background.

Other options for the fairy's hand

9. Inspect the surface for any stray particles. Lay the blue tulle on top of the entire design. Carefully pin the layers; then stitch the layers together with transparent thread. Use clear thread in light areas and smoke thread in the darker areas.

Assembly and Finishing

1. Remove the tear-away stabilizer. Trim the edges of the central design to measure 16½" x 20½".
2. Stitch a 1" x 20½" inner-border strip to the left and right sides of the central design. Stitch the 1" x 17½" inner-border strips to the top and bottom edges. Press the seams toward the inner border.

CAUTION: *Remember that the central design is covered with tulle and the iron should be set at a medium temperature.*

3. Stitch a 3½" x 21½" outer-border strip to the left and right sides of the central design. Stitch the 3½" x 23½" outer-border strips to the top and bottom edges. Press the seams toward the outer border.
4. Layer, baste, quilt, and bind the quilt.
5. Embellish the centers of the flowers as desired.

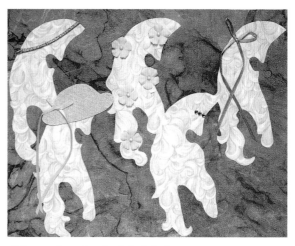

Other options for the fairy's hair

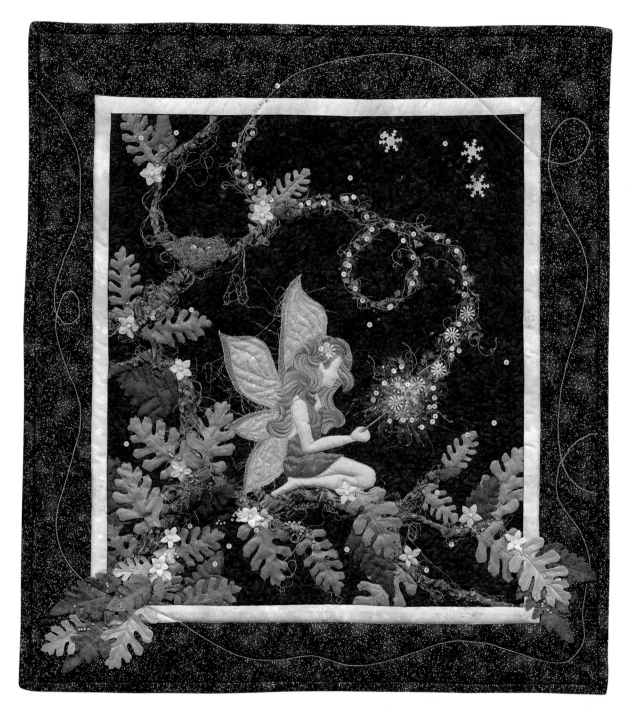

BLUE FAIRY by Sue C. Powell, 2000, Halethorpe, Maryland, 24" x 26½". The sparkling wand and its tail in this design are made with Tintzl, various shapes and sizes of sequins, snippets of glitter tulle, and a thread-wrapped toothpick. Silk flowers and leaves are used both under and on top of the black tulle to create a three-dimensional effect. The branches, made with raveled edges of fabric, also provide a three-dimensional design element. A clump of the raveling threads suggests a nest. The eggs in the nest are really seashells. The wings consist of two layers of fabric; one is a sparkle organza, which gives a more fairylike effect. Beads highlight the flower centers and give a mystical quality to the setting. Beads also appear on the wand trail, which continues into the border. All these elements combine to provide a magical setting for the Blue Fairy in this variation of the "Fantasy Tree Fairy" quilt.

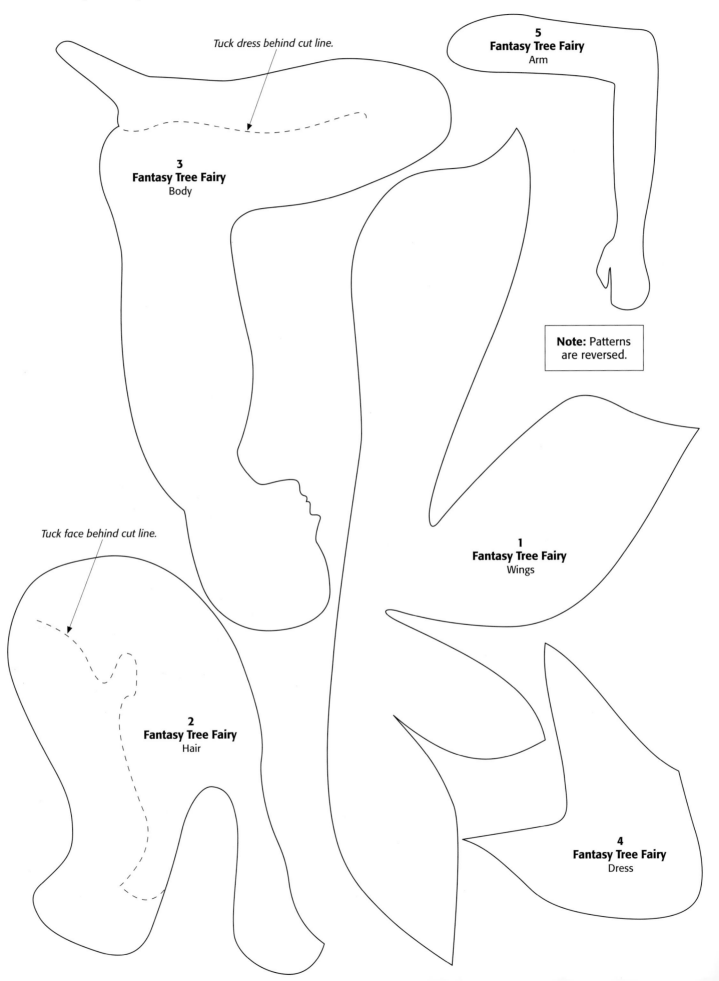

Tuck dress behind cut line.

3
Fantasy Tree Fairy
Body

5
Fantasy Tree Fairy
Arm

Note: Patterns
are reversed.

1
Fantasy Tree Fairy
Wings

Tuck face behind cut line.

2
Fantasy Tree Fairy
Hair

4
Fantasy Tree Fairy
Dress

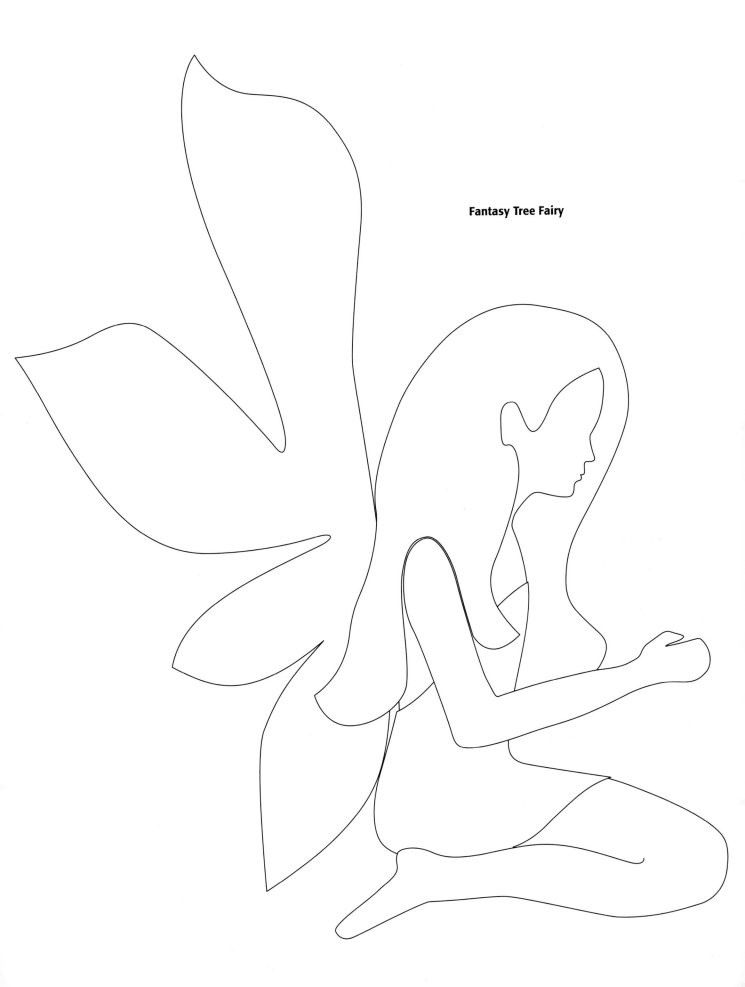

Fantasy Tree Fairy

Valentine Floral Heart

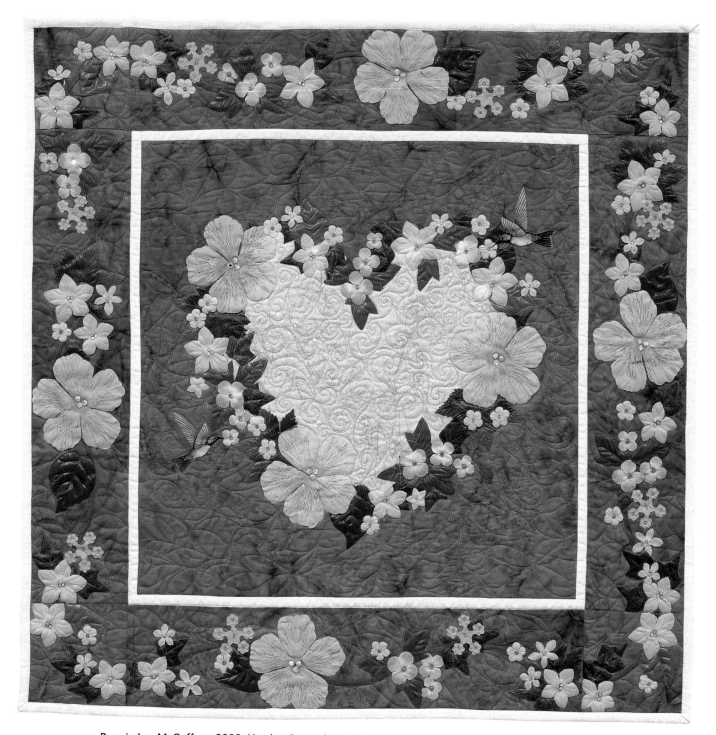

Bonnie Lyn McCaffery, 2000, Hawley, Pennsylvania, 35" x 35". The central design, the corners, and the borders are all individually created fantasy floral fabric pieces that are sewn together.

THIS PROJECT WILL GIVE YOU EXPERIENCE ADDING CAREFULLY CUT NOVELTY PRINTS, EMBELLISHING WITH CREATIVE CRYSTAL IRON-ON RHINESTONES, AND CREATING FANTASY FLORAL BORDERS.

Fabric: 42" wide

- 1 yd. off-white solid for heart, inner border, and binding
- 1 yd. dark pink print for background and outer border
- Scrap of novelty print with 2 birds (or other critters if you desire)
- 1⅛ yds. for backing

Additional Materials

- 13" x 15" piece of paper for heart template (use a paper grocery bag that has been cut open)
- 2¼ yds. Pellon Stitch-n-Tear
- Silk flowers: a selection of small, medium, and large flowers and leaves. I used Teters Floral Products, Inc., Pink Large Delphiniums, Pink Hibiscus Bush, Pink Lilacs, Pink Canadian Hydrangea, Ivy, and Golden Yellow Double Baby's Breath Spray.
- 1 pkg. Watermelon Tintzl
- 1 yd. dark pink tulle
- 1 spool each of smoke and clear transparent thread
- 1 pkg. Brown Clover Quick Bias Tape
- 37" x 37" piece of batting
- Creative Crystal Iron-On Rhinestones: The colors and sizes will depend on the flowers you select. I used Topaz, Rose, and Aurora Borealis in all sizes (10ss, 16ss, 20ss, and 34ss).
- BeJeweler (optional for adhering the rhinestones to the quilt surface)
- Spray starch

Cutting

All measurements include ¼"-wide seam allowances.

From the off-white solid, cut:
- 1 rectangle, 13" x 15", for heart
- 2 strips, each 1" x 24", for inner top and bottom borders
- 2 strips, each 1" x 23", for inner side borders
- 4 strips, each 2" x 42", for binding

From the dark pink print, cut:
- 1 square, 23½" x 23½", for background
- 4 strips, each 6" x 24", for outer side, top, and bottom borders
- 4 squares, each 6" x 6", for outer top and bottom borders

From the tear-away stabilizer such as Pellon Stitch-n-Tear, cut:
- 2 rectangles, each 12" x 24"
- 4 rectangles, each 6" x 24"
- 4 squares, each 6" x 6"

From the tulle, cut:
- 1 square, 24" x 24"
- 4 rectangles, each 7" x 24"
- 4 squares, each 7" x 7"

Creating the Central Design

1. Fold the 13" x 15" paper in half vertically. Draw a heart and cut out the template. Use the heart template to cut a heart from the off-white solid fabric.
2. Press the two 12" x 24" pieces of tear-away stabilizer and lay them on a flat surface, overlapping the long edges about ½" (see page 13). Pin the stabilizer pieces at the edges. The joined piece should measure approximately 24" x 24".
3. Place the dark pink square on top of the stabilizer. Center the heart on the dark pink square; use a ruler to measure if necessary.

4. Position flowers and leaves around the cut edge of the heart. Try to use a pointy leaf to emphasize the top cleavage and bottom point in the heart.

5. Spray the back of the novelty print with starch. Carefully cut 2 birds (or other critters) from the fabric. I chose to have one facing left and one facing right. Handle these birds gently to prevent fraying. Position the birds on the outer edge of the heart as desired.

6. Place some Watermelon Tintzl in the center of the heart.

7. Inspect the surface for any stray particles. Lay the tulle on top of the entire piece. Remove the pins at the edges of the stabilizer. Carefully pin the layers; then stitch the layers together with transparent thread. Use clear thread in light areas and smoke thread in the darker areas.

8. Remove the tear-away stabilizer. Trim the edges of the quilt to measure 23" x 23".

Creating the Corner Squares

1. Trace or photocopy the heart corner template pattern on page 78. Cut the template out.

2. Place the corner template in the corner of a 6" dark pink square as shown. Using the edge of the template as a guide, iron the bias tape along the edge of the template. Repeat for remaining 3 corner squares.

3. Lay a corner square on top of a 6" square of stabilizer. Position flowers and leaves along the bias tape, keeping them at least ¾" from the edges of the square. Work on all 4 corner squares at the same time, which will help insure a balance of flowers around the border.

4. Cover the squares with the 7" squares of tulle. Carefully pin the layers; then stitch the layers together.

Creating the Borders

1. Trace or photocopy the heart border template pattern on page 78. Cut the template out. Fold a 6" x 24" dark pink border strip in half, and then in half again to divide the strip into 4 equal sections of 6" each. Mark each fold with a pin.

2. Starting at one side, position the border template along the edge of the border strip as shown. Using the template as a guide, iron the bias tape along the edge of the template.

3. Flip the template over to get a mirror image and position it in the next 6" section. Iron the bias tape along the edge of the template.

4. Flip the template over again and iron the bias tape in the third section of the border. Flip the template one more time and iron the bias tape in the last section. Do all 4 borders in the same manner.

5. Lay a border piece on top of a 6" x 24" piece of stabilizer. Position flowers and leaves along the bias tape stem, leaving some of the stem showing. Keep the flowers and leaves at least ¾" away from the edges of the fabric. Work on all 4 borders at the same time, which will help insure a balance of flowers around the border.

6. Cover each of the border strips with the 7" x 24" rectangles of tulle. Pin and stitch the layers together with transparent thread. Use clear in the light areas and smoke in the darker areas.

Assembly and Finishing

1. Remove the tear-away stabilizer from all prepared pieces. Trim the excess tulle so it is even with the edge of the fabric.
2. Stitch the 1" x 23" inner-border strips to the left and right sides of the central design. Stitch the 1" x 24" inner-border strips to the top and bottom of the central design. Press seam allowances toward the inner-border strips.

CAUTION: *Remember that the central design is covered with tulle and the iron should be set at a medium temperature.*

3. Lay out all parts of the quilt, carefully positioning the corner squares and borders. The borders should be positioned so the stems match up with the corner square stems.

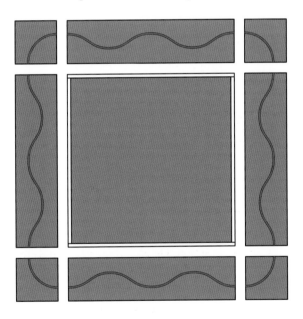

4. Stitch the side outer-border strips to the left and right sides of the central design. Press the seams toward the border strips. Stitch the corner squares to the corresponding top and bottom borders, and press the seams toward the border strips. Stitch these to the top and bottom edges. Press the seams toward the border strips.
5. Layer, baste, quilt, and bind the quilt.
6. Finish the centers of the flowers by filling them with Creative Crystal Iron-On Rhinestones. These can be single rhinestones or groupings of three.

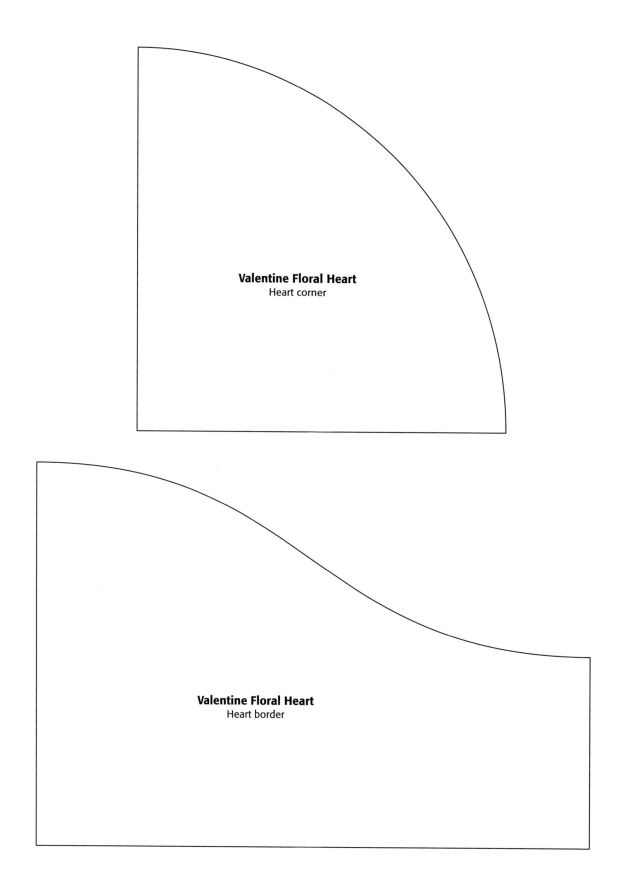

Valentine Floral Heart
Heart corner

Valentine Floral Heart
Heart border

Bibliography

Eha, Nancy. *Off the Beadin' Path: Discovering Your Own Creative Trail of Bead Embellishment.* St. Paul, Minn.: Creative Visions Press, 1999.

Hunter, Norah T. and Herb Mitchell. *The Art of Floral Design.* Albany, N.Y.: Delmar, 2000.

McCaffery, Bonnie Lyn. *Fantasy Fabrics: Techniques for Layered Surface Design.* Bothell, Wash.: Martingale & Company, 1999.

Montano, Judith Baker. *The Art of Silk Ribbon Embroidery.* Lafayette, Calif.: C & T Publishing, 1993.

Nelson, Pat. *Stylish Sewing: Techniques for Quilted and Embellished Clothing.* Bothell, Wash.: Martingale & Company, 2000.

Samples, Carole. *Treasury of Crazy Quilt Stitches.* Paducah, Ky.: American Quilter's Society, 1999.

Resources

Beacon Adhesives Signature Crafts
PO Box 427
Wyckoff, NJ 07481
Phone: (800) 865-7238
Web site: www.beacon1.com
Gem-Tac and Fabri-Tac

Creative Crystal Company
Phone: (800) 578-0716
Web site:
www.creative-crystal.com
Creative Crystal embellishments and BeJeweler

eQuilter.com
4699 Nautilus Court South
Suite #404
Boulder, CO 80301
Phone: (877) FABRIC3 and
(303) 527-0856
Web site: www.eQuilter.com
Online source for Tintzl, books, quilting fabrics, and accessories

Falk Industries
Available at your local fabric store
Tulle

Hoffman California Fabrics
Mission Viejo, CA 92691
Available at your local quilt shops
Fabrics

Bonnie McCaffery
View more of her quilts on her
Web site at
http://home.ptd.net/~bmccaffe

Northern Star
PO Box 409
Kauneonga Lake, NY 12749-0409
Phone: (866) 583-0229
E-mail: lnixon@warwick.net
Machine-quilting services

Prym-Dritz Corporation
PO Box 5028
Spartanburg, SC 29304
Web site: www.dritz.com
Variety of sewing products

Timeless Treasures Fabrics, Inc.
483 Broadway
New York, NY 10013
Web site: www.ttfabrics.com
Available at your local fabric stores
and quilt shops
Fabrics

Teters Floral Products, Inc.
Available at your local craft store
Silk flowers

YLI Corporation
161 West Main St.
Rock Hill, SC 29730
Phone: (800) 296-8139 and
(803) 985-3100
Web site: www.ylicorp.com
E-mail: ylicorp@ylicorp.com
Candlelight Yarn, Wonder Invisible Thread, Fine Metallic Thread, Silk Ribbon, Spark Organdy, Hand Dyed Silk Ribbon, and a variety of other great threads

Z-Barten Productions
2150 Sacramento St.
Los Angeles, CA 90021
Phone: (800) CONFETTI
Web site: www.confetti.com
Tintzl

About the Author

Bonnie McCaffery lives in Hawley, Pennsylvania, and is a wife and a mother of three teenage daughters. Quilting is her life. She has been an active member of the Milford Valley Quilters Guild since it first started about 11 years ago. She also enjoys traveling and lecturing to quilt guilds far and wide. In March 2000, she lectured in England, Scotland, Ireland, and France.

In addition to traveling and lecturing, Bonnie loves to design and teach. Her specialties are fantasy fabric, kaleidoscope quilts, free-form appliqué quilts, and dimensional quilts. These quilts are by no means traditional; rather, they are art pieces. She is always trying to stretch quilting to its limits. Numerous projects of Bonnie's and articles about her quilts have been published in *Art Quilt Magazine*, *British Patchwork*, *McCall's Quilting*, *American Quilter's Society Magazine*, *Quilting International*, *Quilter's Newsletter Magazine*, and *Craftworks*.

Bonnie's talent has also brought her awards. In 1998, she received the Jewel Pearce Patterson Scholarship to attend the European Quilt Market and the International Quilt Festival in Innsbruck, Austria. Only one quilter is selected each year to receive this prestigious award.

Fantasy Floral Quilts is Bonnie's second book. Her first book, *Fantasy Fabrics: Techniques for Layered Surface Design* (Martingale & Company, 1999), explored the possibilities of capturing various things (including cut fabrics, feathers, threads, yarns, and lots more) under a sheer top layer of fabric to create a new fabric that could be framed, pieced, or appliquéd.